IMPRESSIONS of the
SOUTH DOWNS

Produced by AA Publishing

© Automobile Association Developments Limited 2008

All rights reserved. No part of this publication may be reproduced, stored in
a retrieval system, or transmitted in any form or by any means – electronic,
photocopying, recording or otherwise – unless the written permission of the
publishers has been obtained beforehand.

Published by AA Publishing (a trading name of Automobile Association
Developments Limited, whose registered office is Fanum House, Basing View,
Basingstoke, Hampshire RG21 4EA; registered number 1878835)

ISBN 978-0-7495-5549-8

A03033g

A CIP catalogue record for this book is available from the British Library.

The contents of this book are believed correct at the time of printing. Nevertheless,
the publishers cannot be held responsible for any errors, omissions or for changes in
the details given in this book or for the consequences of any reliance on the
information provided by the same. This does not affect your statutory rights.

Colour reproduction by KDP, Kingsclere
Printed and bound in China by C&C Offset Co Ltd

Opposite: Signpost on the South Downs

IMPRESSIONS *of the*
SOUTH DOWNS

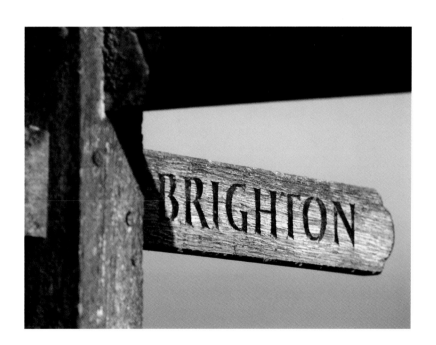

Acknowledgements

The Automobile Association wishes to thank the following photographers, companies and picture libraries for their assistance in the preparation of this book.

Abbreviations for the picture credits are as follows: (AA) AA World Travel Library

F/C AA/J Miller; B/C AA/J Miller; B/C inset AA/M Moody; 3 AA/J Miller; 5 AA/D Croucher; 7 AA/J Miller; 8 AA/S & O Mathews; 9 AA/W Voysey; 10 AA/M Busselle; 11 AA/J Miller; 12 AA/J Miller; 13 AA/M Moody; 14 AA/J Miller; 15 AA/J Miller; 16 AA/D Noble; 17 AA/M Busselle; 18 AA/J Miller; 19 AA/J Miller; 20 AA/M Moody; 21 AA/M Moody; 22 AA/M Moody; 23 AA/J Miller; 24 AA/J Miller; 25 AA/J Miller; 26 AA/J Miller; 27 AA/J Miller; 28 AA/M Busselle; 29 AA/M Moody; 30 AA/M Busselle; 31 AA/S Day; 32 AA/J Miller; 33 AA/J Miller; 34 AA/S & O Mathews; 35 AA/M Moody; 36 AA/J Miller; 37 AA/J Miller; 38 AA/J Miller; 39 AA/J Miller; 40 AA/M Moody; 41 AA/M Moody; 42 AA/J Miller; 43 AA/M Moody; 44 AA/J Miller; 45 AA/J Miller; 46 AA/J Miller; 47 AA/S & O Mathews; 48 AA/J Miller; 49 AA/J Miller; 50 AA/J Miller; 51 AA/J Miller; 52 AA/M Moody; 53 AA/S Day; 54 AA/J Miller; 55 AA/J Miller; 56 AA/J Miller; 57 AA/J Miller; 58 AA/D Forss; 59 AA/J Miller; 60 AA/D Croucher; 61 AA/J Miller; 62 AA/M Moody; 63 AA/J Miller; 64 AA/J Miller; 65 AA/J Miller; 66 AA/J Miller; 67 AA/J Miller; 68 AA/M Trelawny; 69 AA/T Souter; 70 AA/P Brown; 71 AA/J Miller; 72 AA/ J Miller; 73 AA/J Miller;74 AA/J Miller; 75 AA/J Miller; 76 AA/J Miller; 77 AA/ J Miller; 78 AA/J Miller; 79 AA/J Miller; 80 AA/ J Miller; 81 AA/J Miller; 82 AA/J Miller; 83 AA/T Souter; 84 AA/J Miller; 85 AA/S & O Mathews; 86 AA/J Miller; 87 AA/J Miller; 88 AA/J Miller; 89 AA/M Busselle; 90 AA/M Moody; 91 AA/ J Miller; 92 AA/J Miller; 93 AA/J Miller; 94 AA/J Miller; 95 AA/ J Miller.

Every effort has been made to trace the copyright holders, and we apologise in advance for any unintentional omissions or errors. We would be pleased to apply any corrections in any following edition of this publication.

Opposite: A dry valley in a fold beneath the Downs

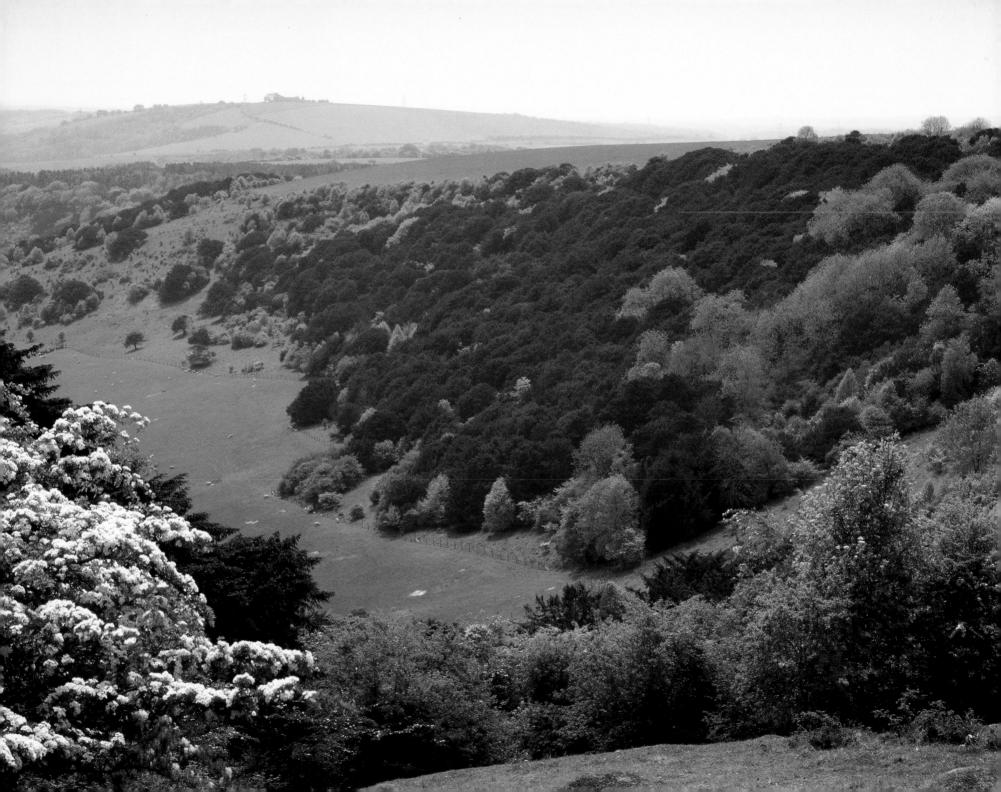

INTRODUCTION

The South Downs extends from near Winchester in Hampshire to tend in spectacular fashion at the dizzying cliff of Beachy Head above Eastbourne in East Sussex. Big centres of population are never far away, but high up on the Downs, with skylarks and the occasional paraglider for company, this is an exhilarating escape from the pressures of the modern world. There are few settlements up here and a wonderful sense of space and remoteness, and the South Downs Way provides a memorable passage of its entire length for walkers, cyclists and horse riders.

On the northern side, much of the South Downs are edged by a steep escarpment, looking over the hedged patchwork of the Weald towards the Surrey hills and the North Downs. Here the slopes are often too steep for ploughing and the land has avoided agricultural improvement. Herb-rich grasslands flourish, and there are great varieties of chalk-loving wildflowers such as orchids and butterflies like the scarce chalkhill blue. Dotted over the area are all kinds of mementoes to settlers from many centuries back, including Neolithic flint mines, Bronze Age burial mounds and Iron Age hillforts, while beneath the escarpment Roman villas such as Bignor are strategically sited for some very lovely views – a reminder that our distant ancestors enjoyed looking at the scenery as much as we do. For much of the southern side, the Downs dip more gently towards the sea. Further east, after the Downs end, the Sussex coast continues beyond Hastings, with its delightful Old Town and sandstone cliffs, to the medieval town of Rye.

This stretch of terrain has been long fought over, civilised, savoured and written about as much as anywhere else in Britain. William the Conqueror, victorious over King Harold at Battle, near Hastings, erected a chain of Norman castles across the breadth of Sussex to show who was in charge. Authors Rudyard Kipling, Virginia Woolf, Jane Austen, Izaak Walton, Gilbert White and Hilaire Belloc are among many to have found literary inspiration here. And the lure of the sea brought the first seaside pleasure-seekers, after the Prince Regent set the fashion for staying in Brighton in his exotic Royal Pavilion. During the Victorian railway age, Brighton became a prime weekend spot for Londoners, and it has evolved into one of the most distinctive and vibrant of all British seaside towns.

The images in this book show a cross-section of the extraordinary variety that makes up the South Downs, its seaboard and its hinterland. It takes us to the coast, with its brightly painted beach huts overlooking shingle shores, fetchingly ornate seaside piers, stripy deckchairs and towering chalk cliffs such as the Seven Sisters that make such a dramatic contrast from the densely developed shoreline. There are encounters too with the extraordinary range of building styles in the region, from the magnificence of the cathedrals at Winchester and Chichester to the understated charm of the local building styles, which feature tile-hanging, half timbering, brick, knapped flint, thatch and weatherboarding – barns, windmills, centuries-old pubs, medieval streets, Georgian townscapes and Victorian cottages.

And then there are the Downs themselves, which somehow never look the same from one mile to the next: waving wheat fields, gated tracks fringed by cow parsley, grassy slopes flecked with gorse bushes, and sheep-nibbled pastures. It is no coincidence that during World War II, propaganda posters urging people to fight for Britain featured the South Downs landscape: it is a scene that conjures up the essence of rural England.

On Sussex's long coastline of shingle and low-tide sand

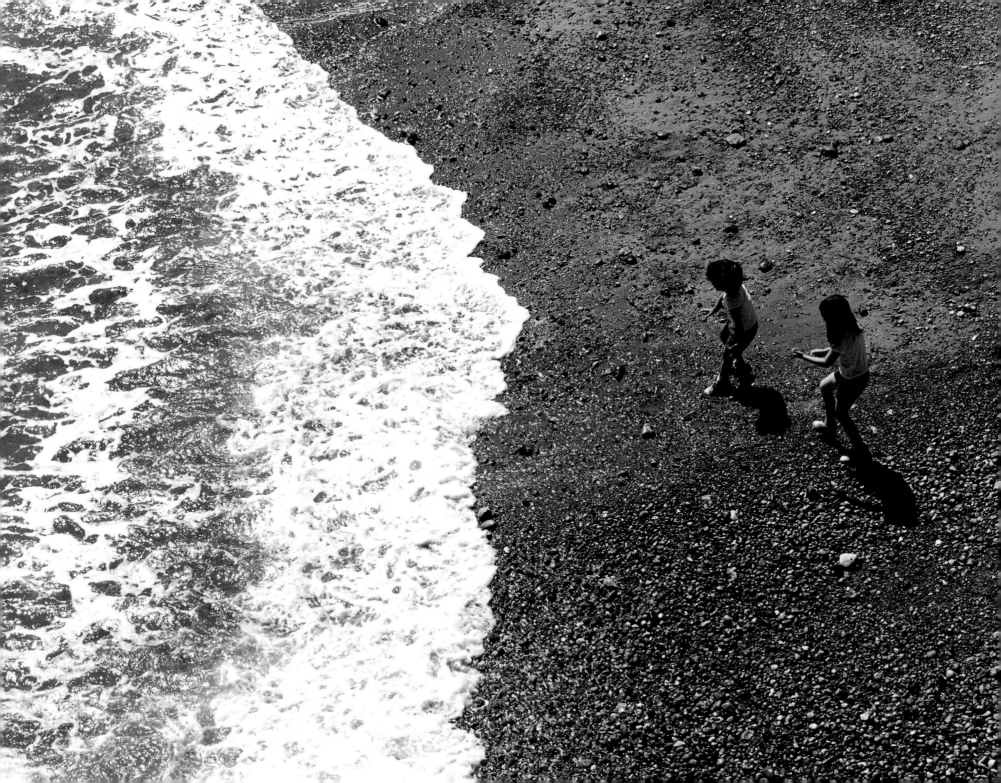

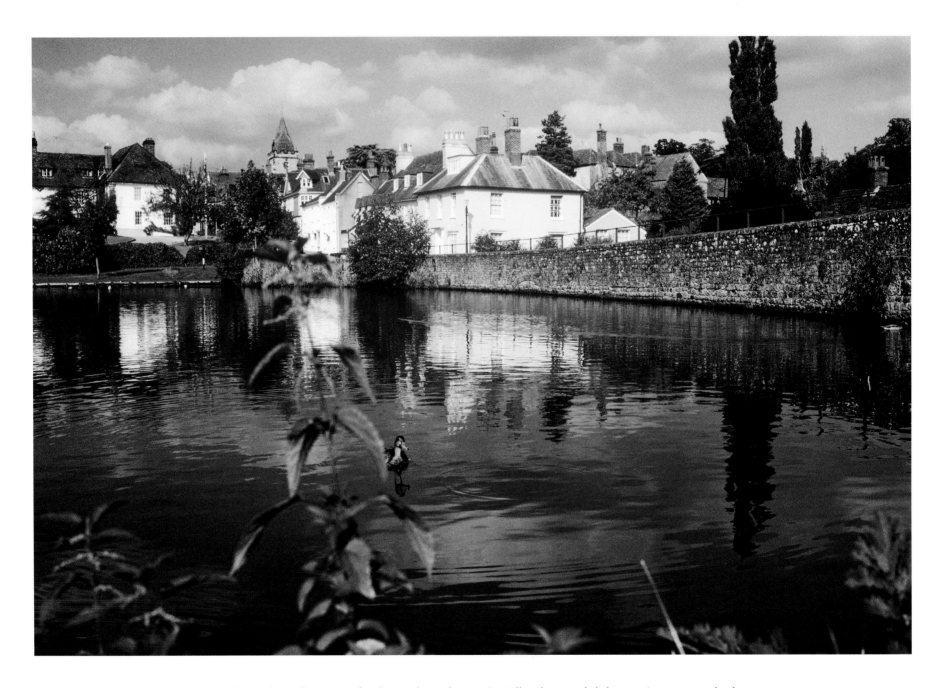

South Pond, Midhurst, was familiar to the author H.G.Wells, who attended the town's grammar school

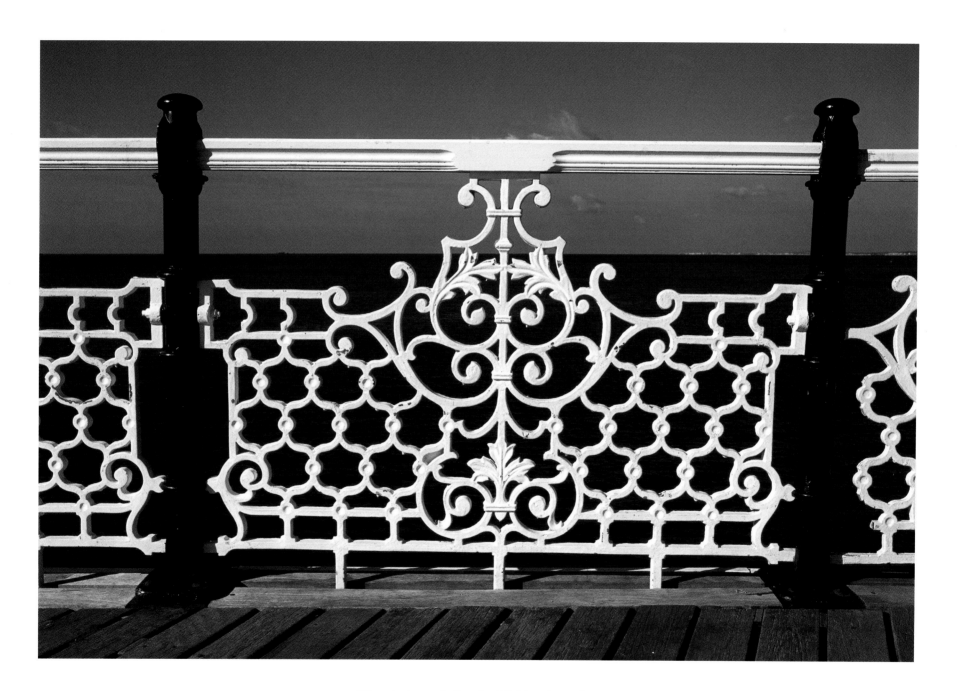

Wrought iron: a hallmark of Brighton's sea front

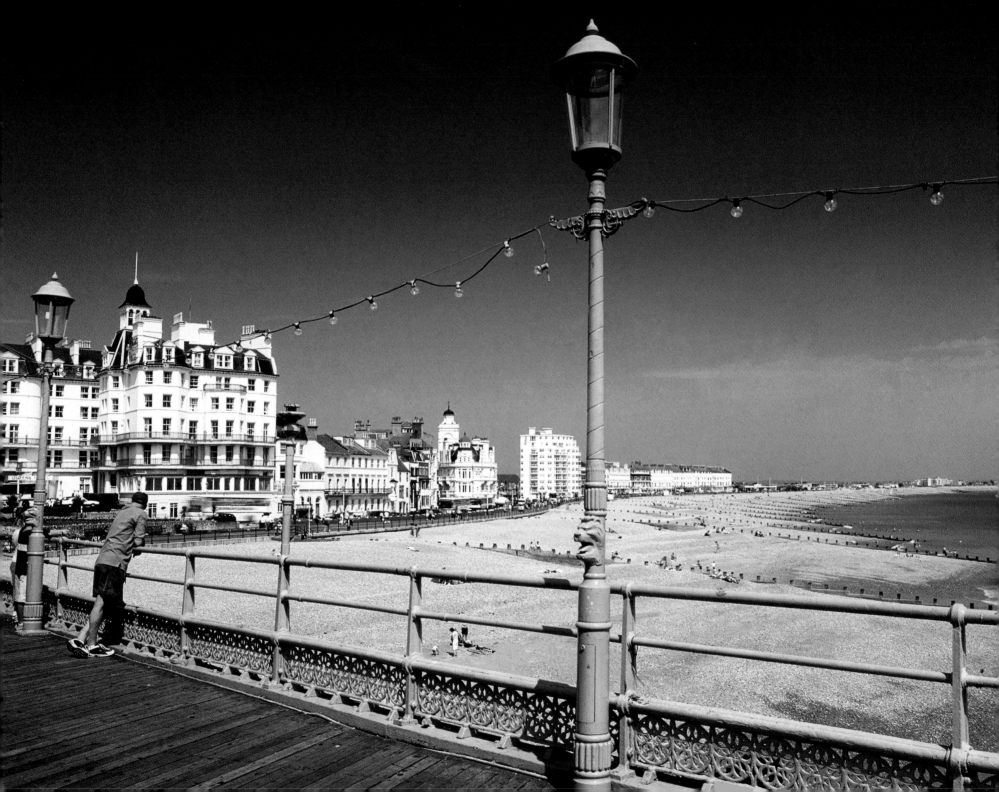

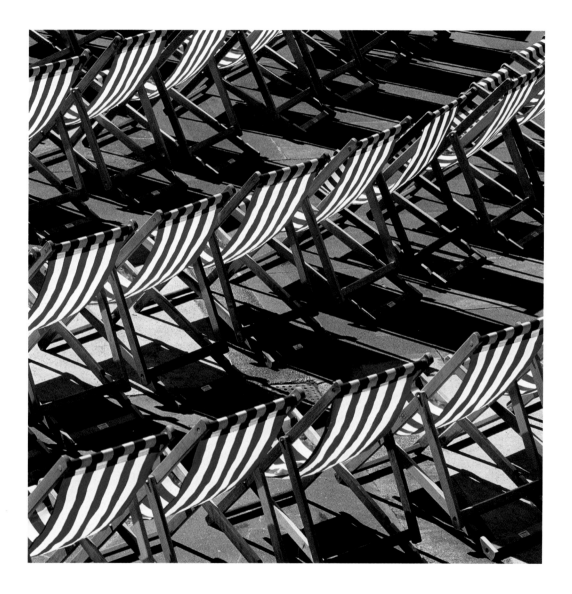

Deckchairs line the beach at Eastbourne
Opposite: Looking over Eastbourne promenade across the beach

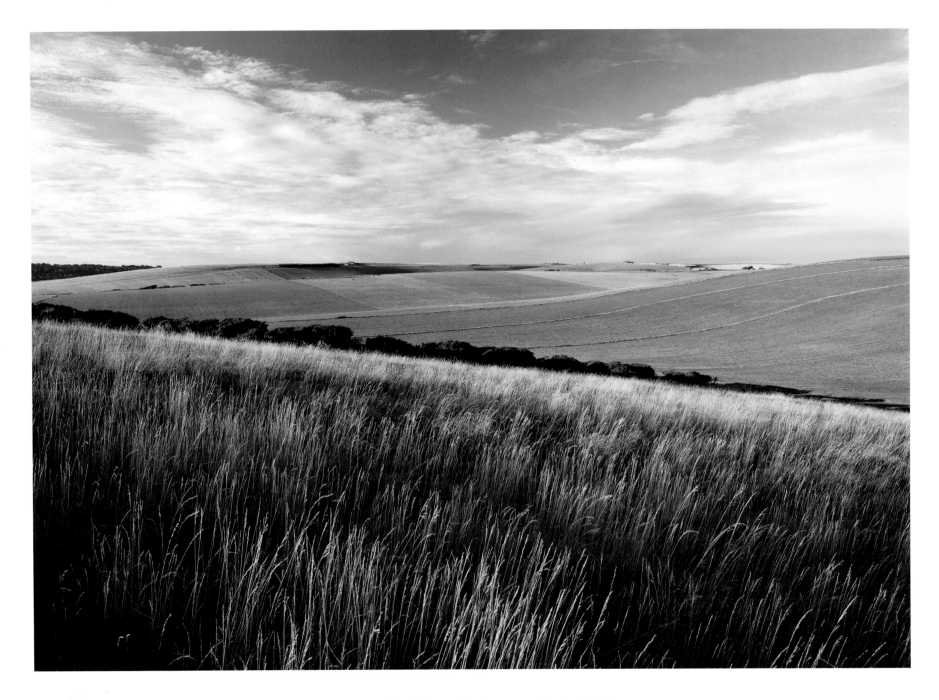

Rolling wheat fields on the Downs near Beachy Head

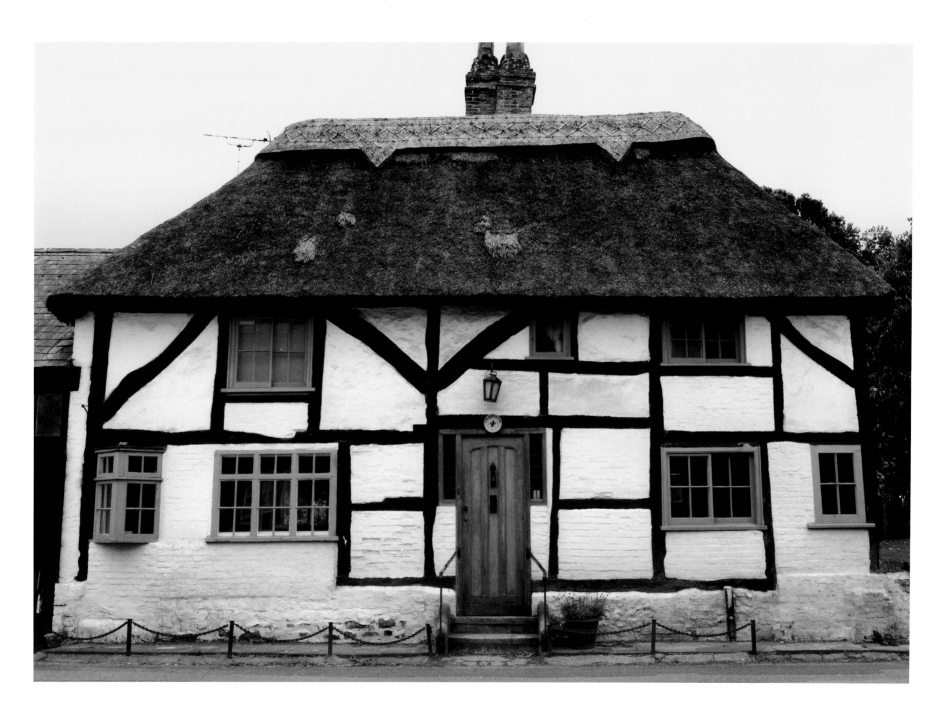

Hampshire thatch as seen at East Meon

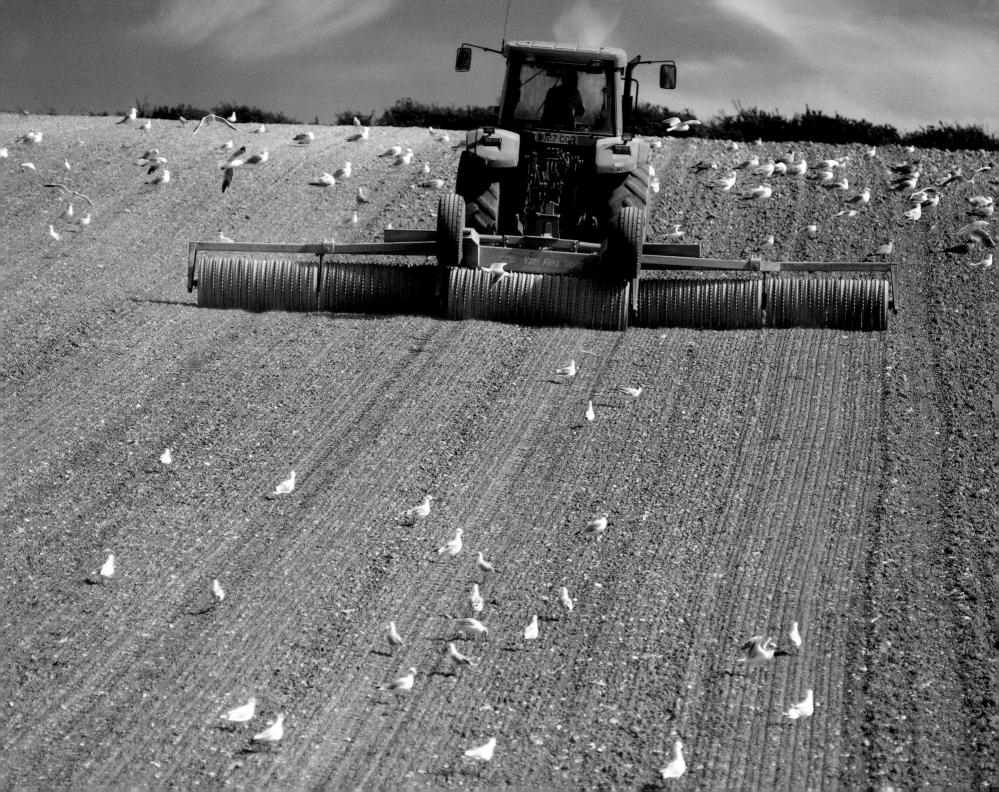

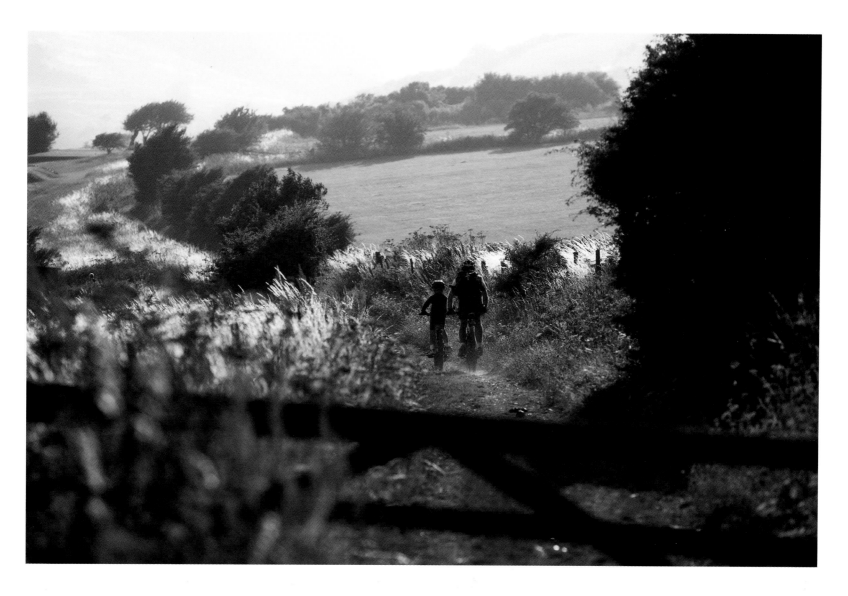

Mountain biking along the South Downs Way
Opposite: Gulls forage in a flint-strewn field

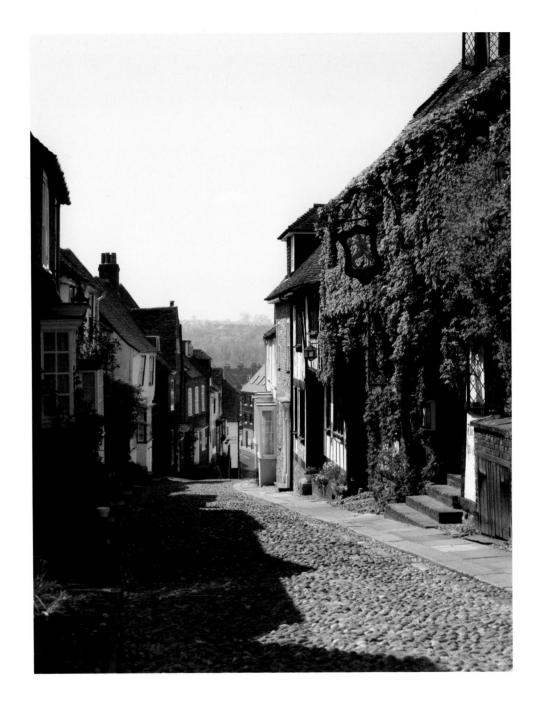

The creeper-covered Mermaid Inn, in Rye's cobbled Mermaid Street

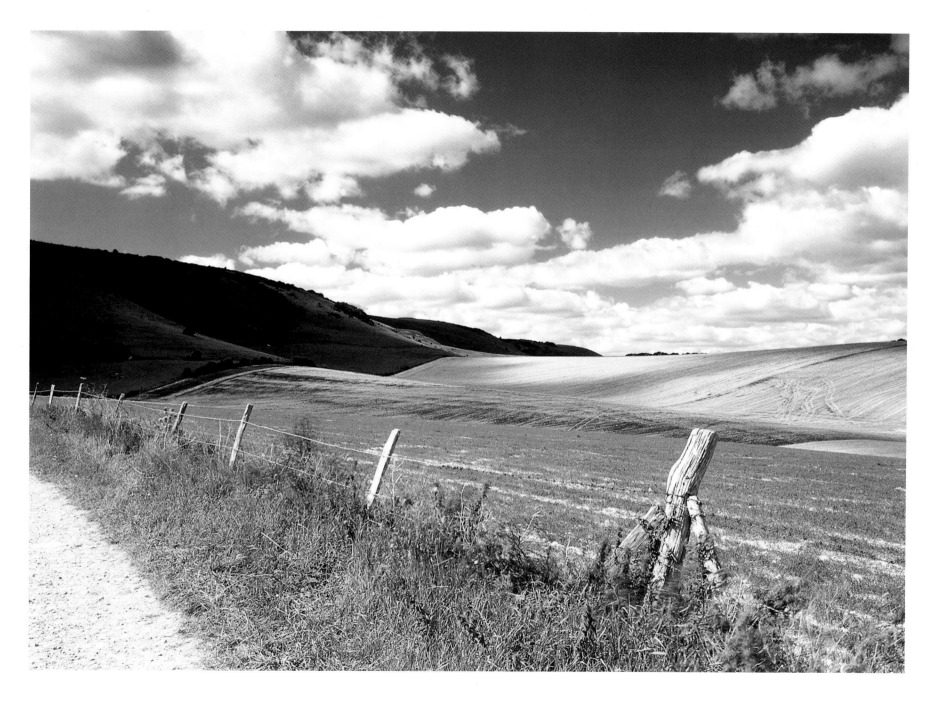

Beneath the escarpment near Alfriston, East Sussex

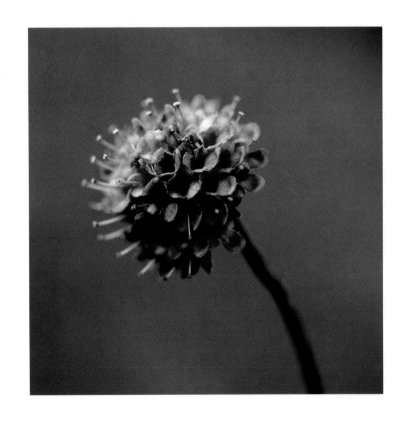

Scabious growing on the Downs at Devil's Dyke
Opposite: The roller-coaster clifftops of the Seven Sisters, with Belle Tout beyond

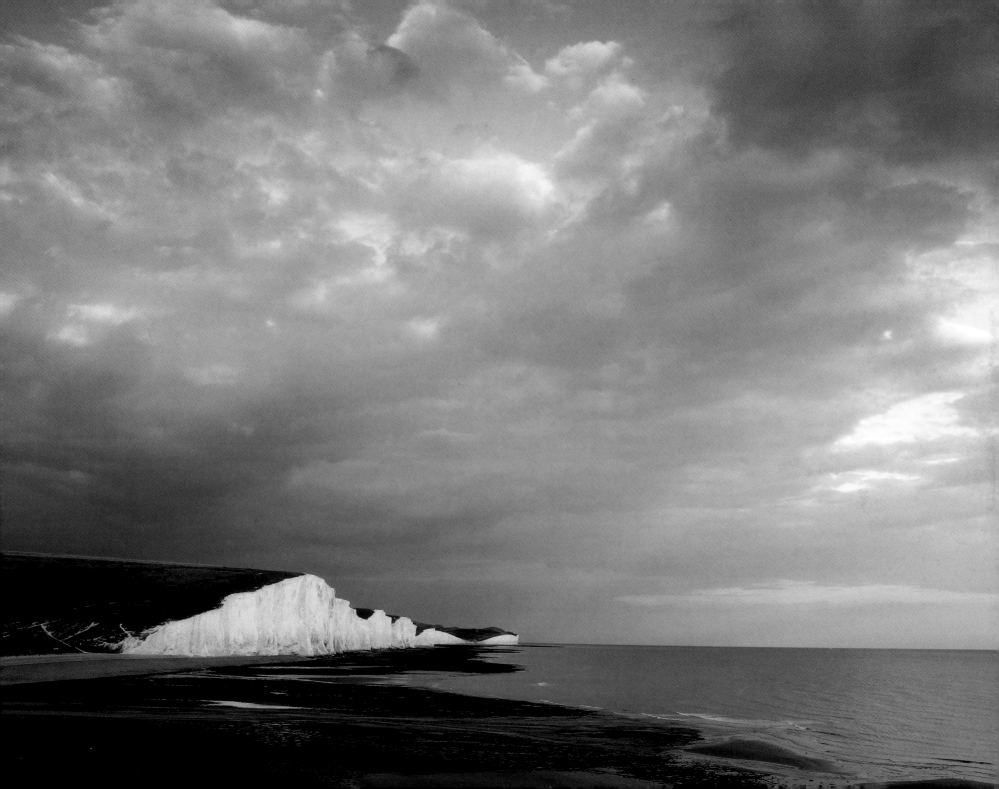

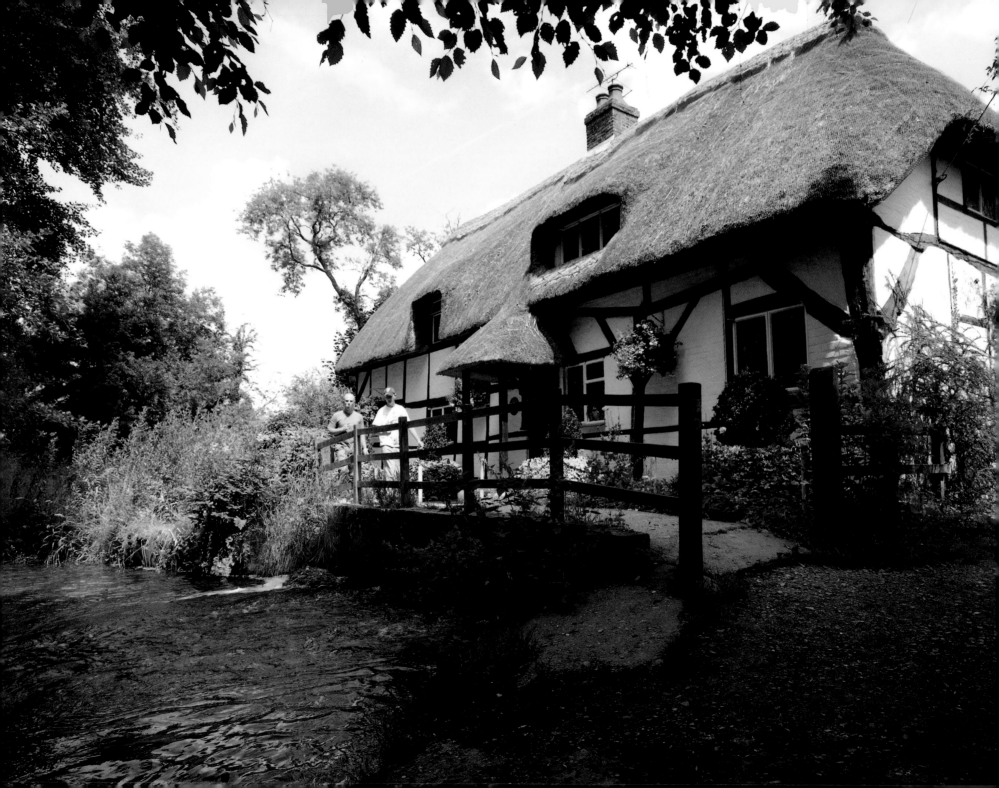

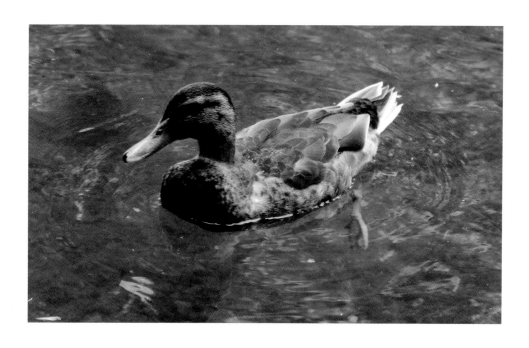

The clear, duck-frequented waters of the Arle in Hampshire
Opposite: A medieval fulling mill on the River Arle, in Alresford

In the garden of Gilbert White, the famous pioneer naturalist, in Selborne

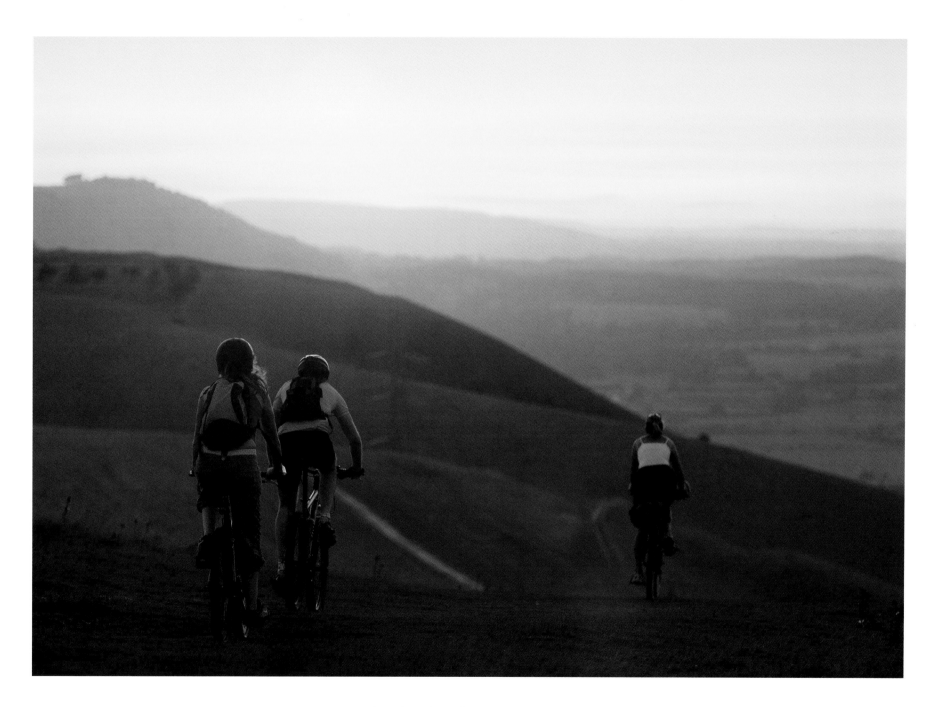

Cycling along the Fulking escarpment at dusk

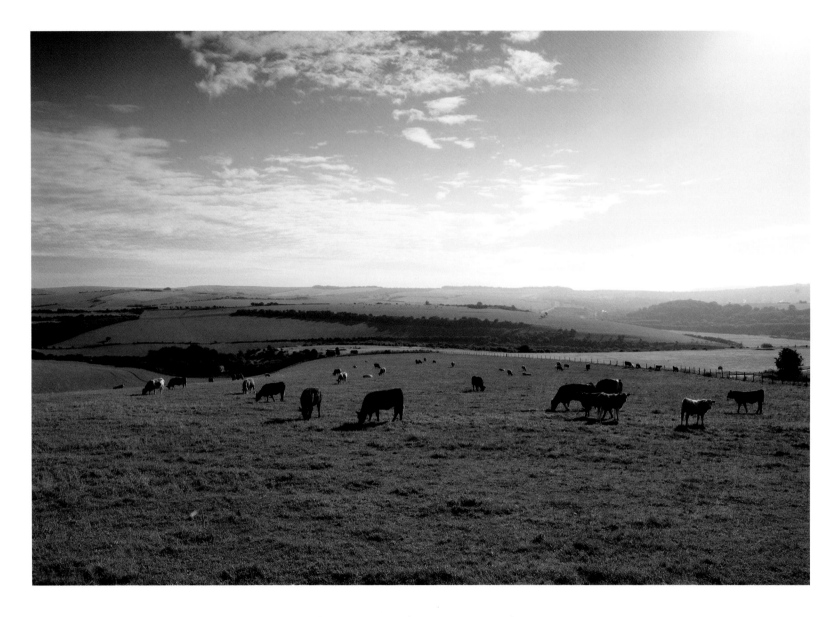

Cows grazing on the Downs near Brighton
Opposite: A wide expanse of beach at Camber Sands

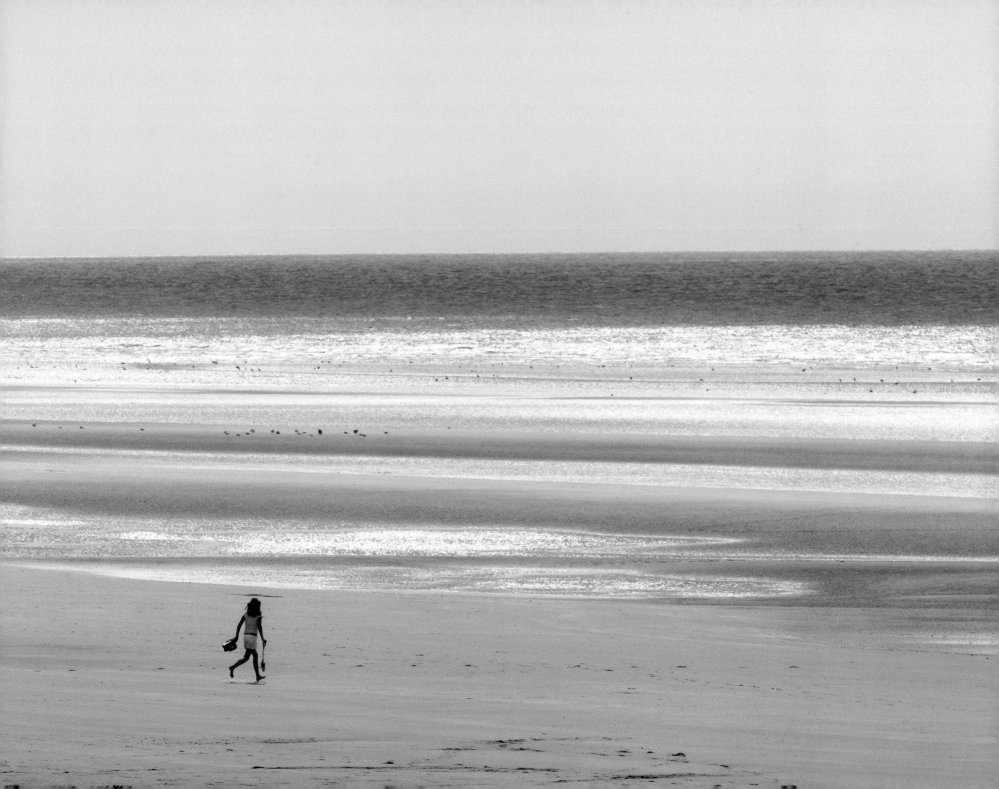

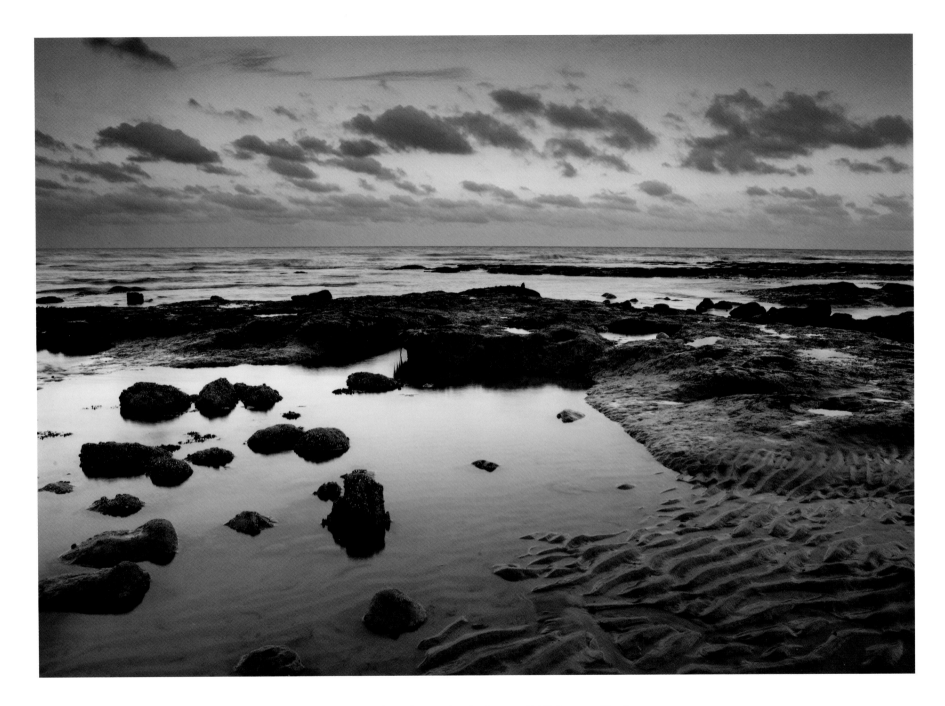

Sands and rock pools on a lonely shore at Fairlight, near Hastings

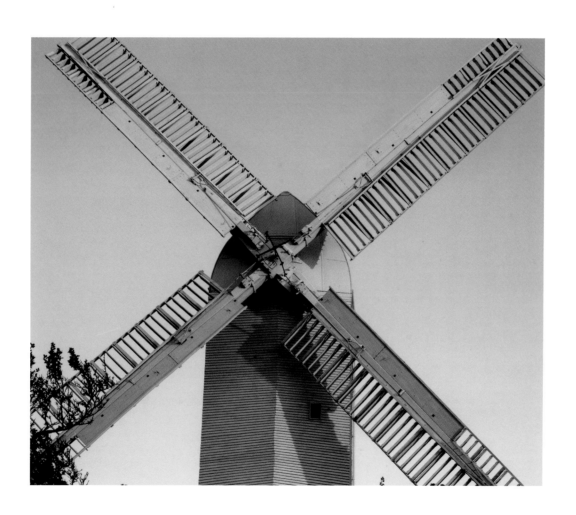

Jill, a corn mill near Clayton, is restored to working order and stands close to another windmill known as Jack

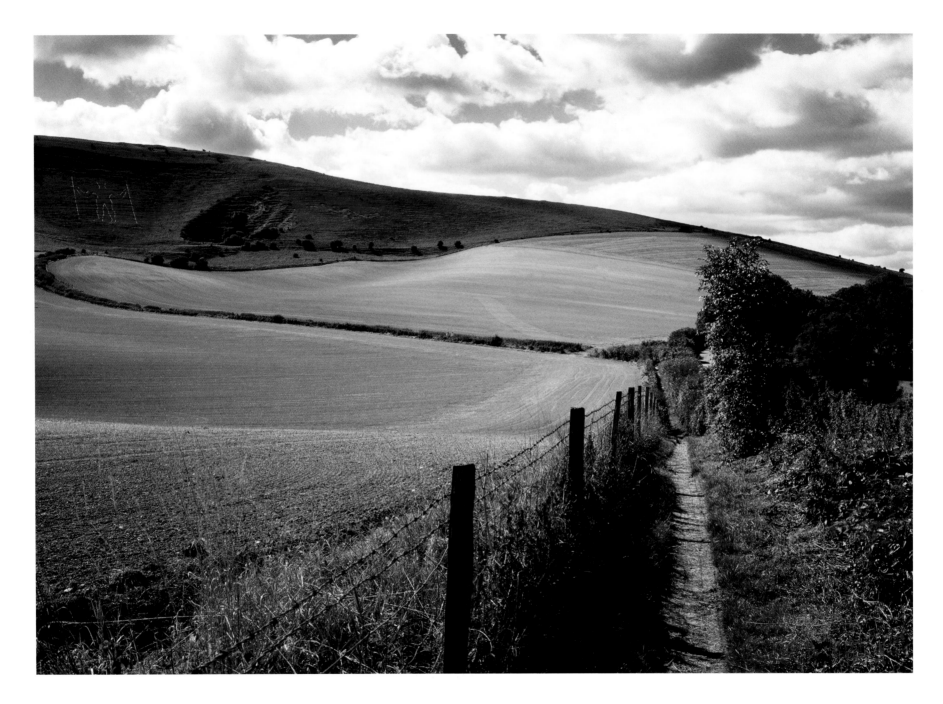

A footpath skirts fields below the escarpment near Wilmington

Pastel-coloured rendering in Alresford, regarded as Hampshire's finest Georgian town

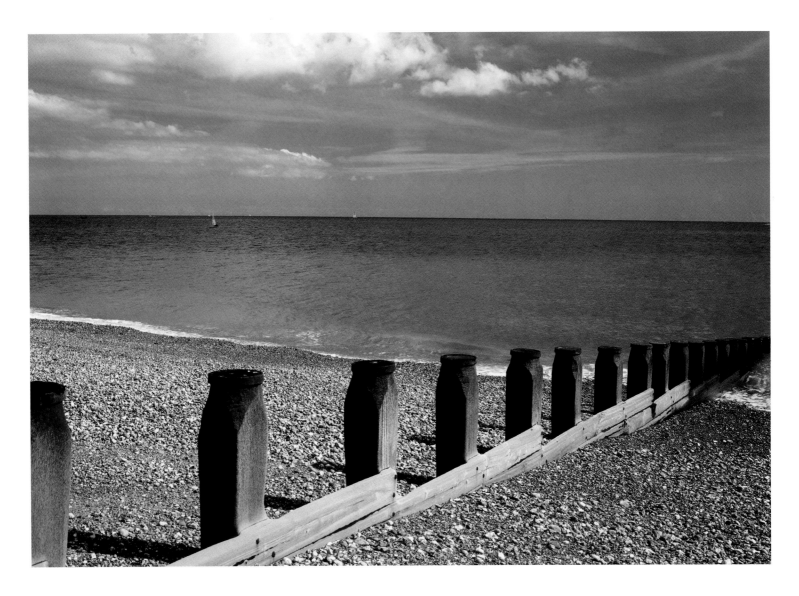

Groynes on Brighton beach limit the movement of shingle along the shore
Opposite: A detail of Winchester Cathedral's fascinating roof, partly painted and partly fan vaulted

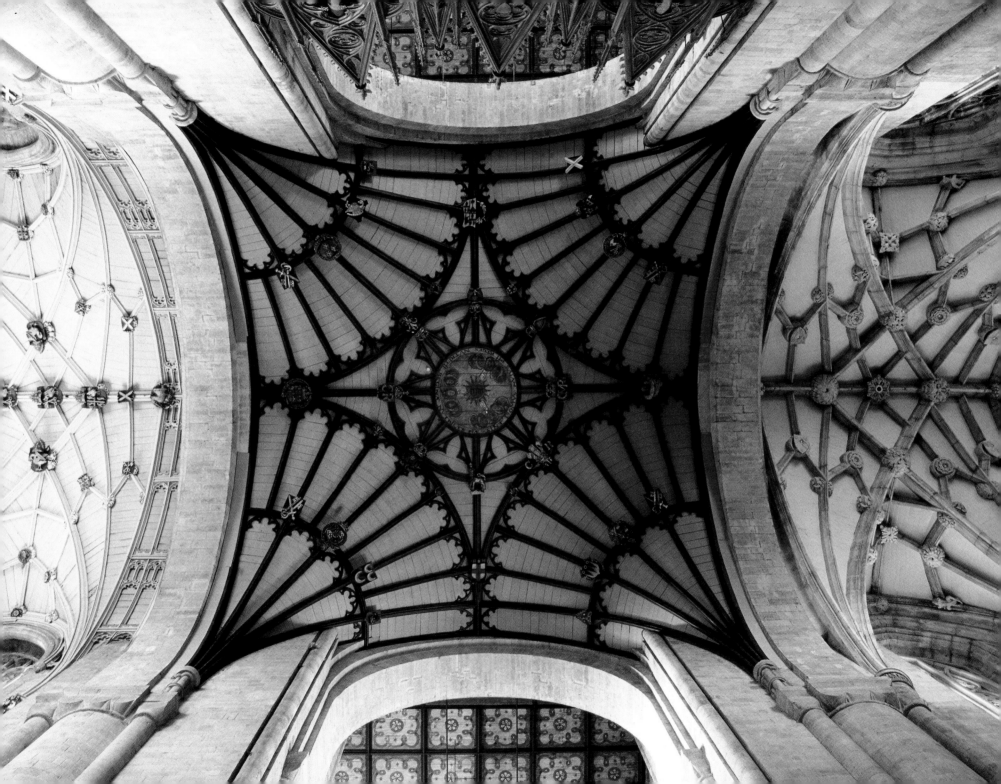

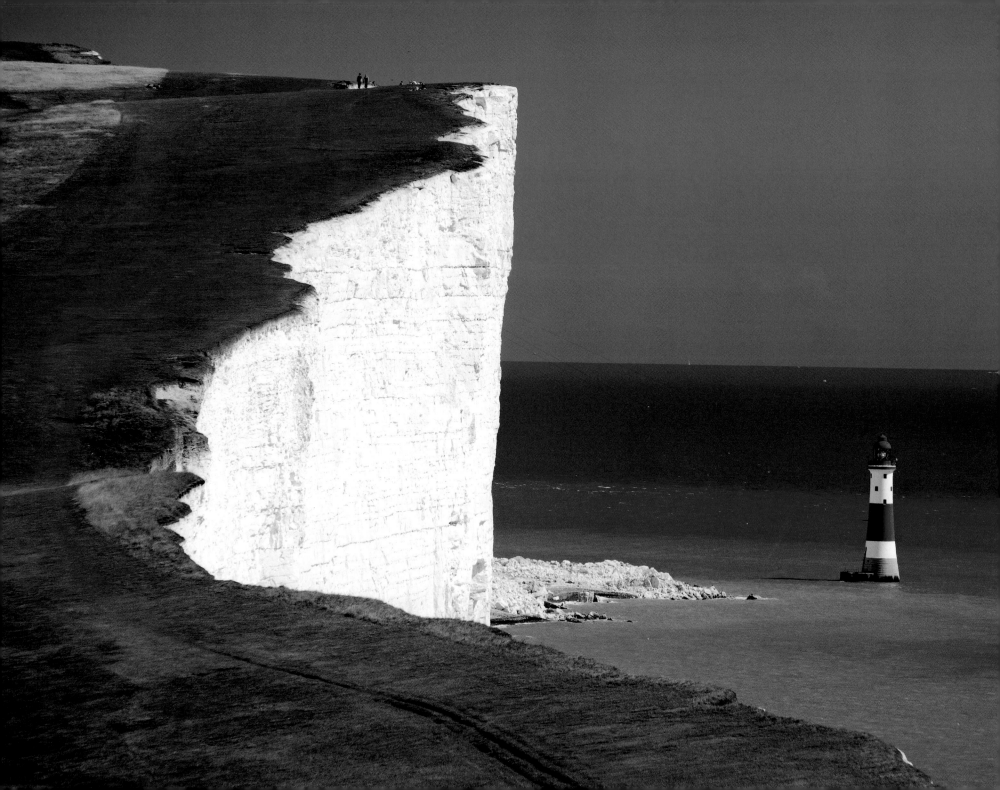

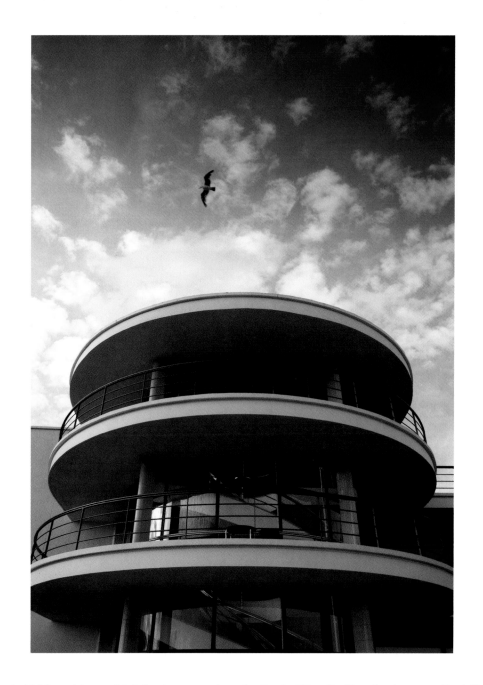

A 1930s architectural Modernist masterpiece: the De La Warr Pavilion, by the sea at Bexhill

Opposite: Beachy Head lighthouse, beneath the highest cliff in south-east England

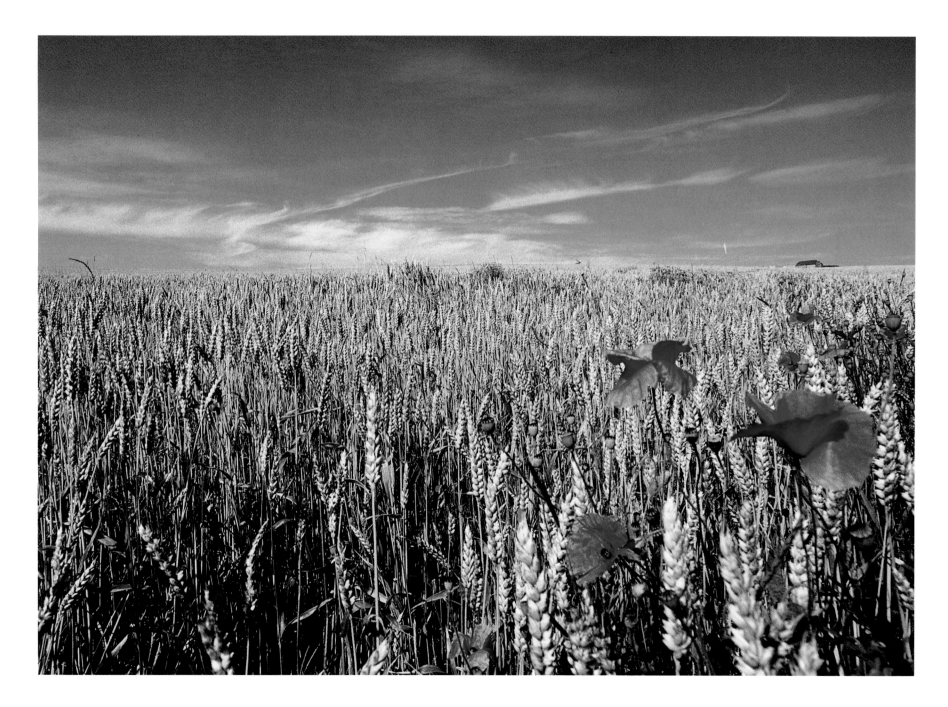

Bright red poppies interrupt a seemingly boundless field of wheat beneath an expansive sky

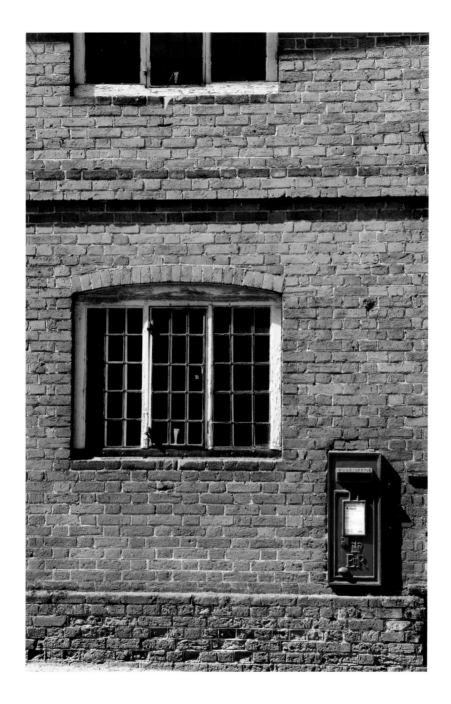

Shades of red in an old cottage wall at Selborne

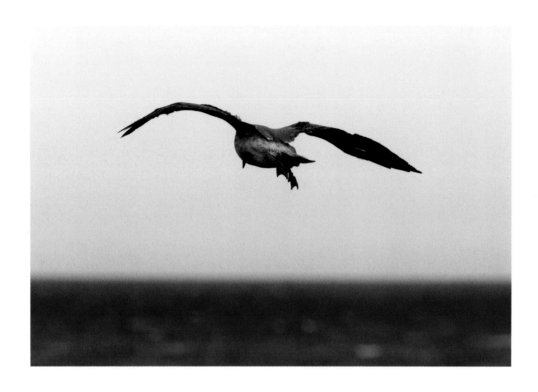

A gull prospects for its next meal near Eastbourne
Opposite: Eastbourne's delightfully ornate Victorian pier includes a camera obscura for viewing the surroundings

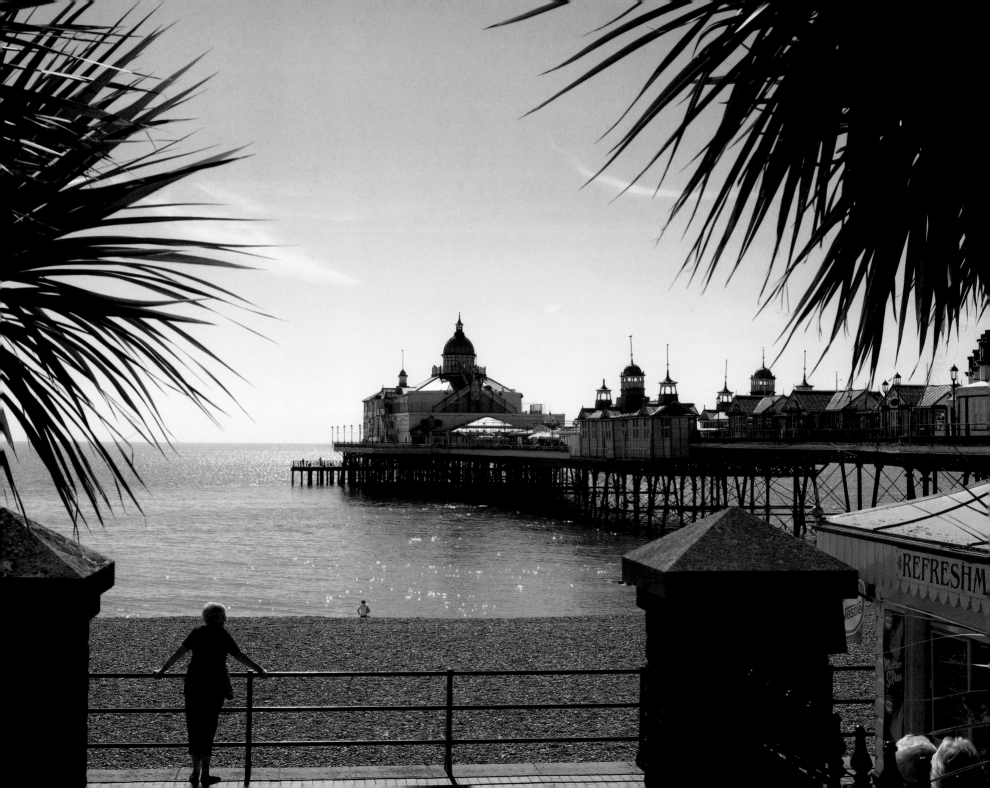

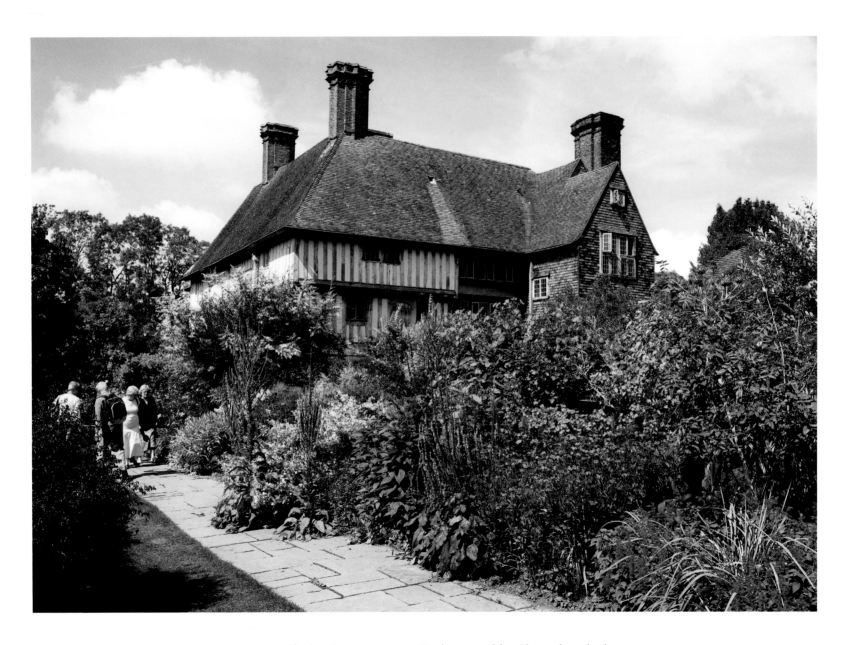

A riot of colour in Great Dixter Garden, created by Christopher Lloyd
Opposite: The finale of the South Downs Way, on the Seven Sisters

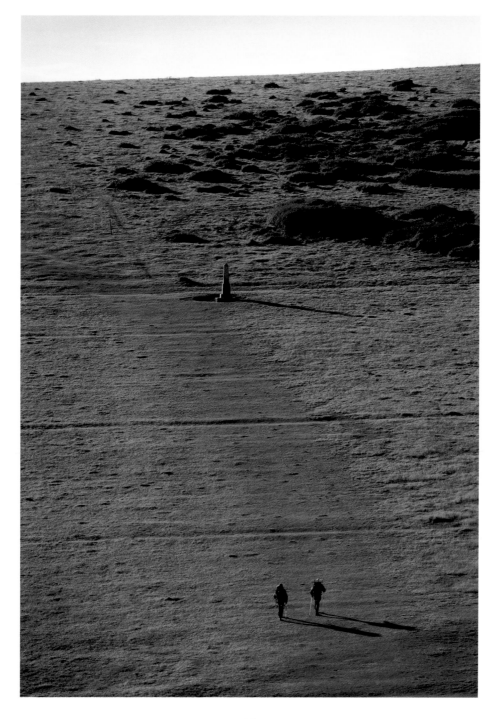

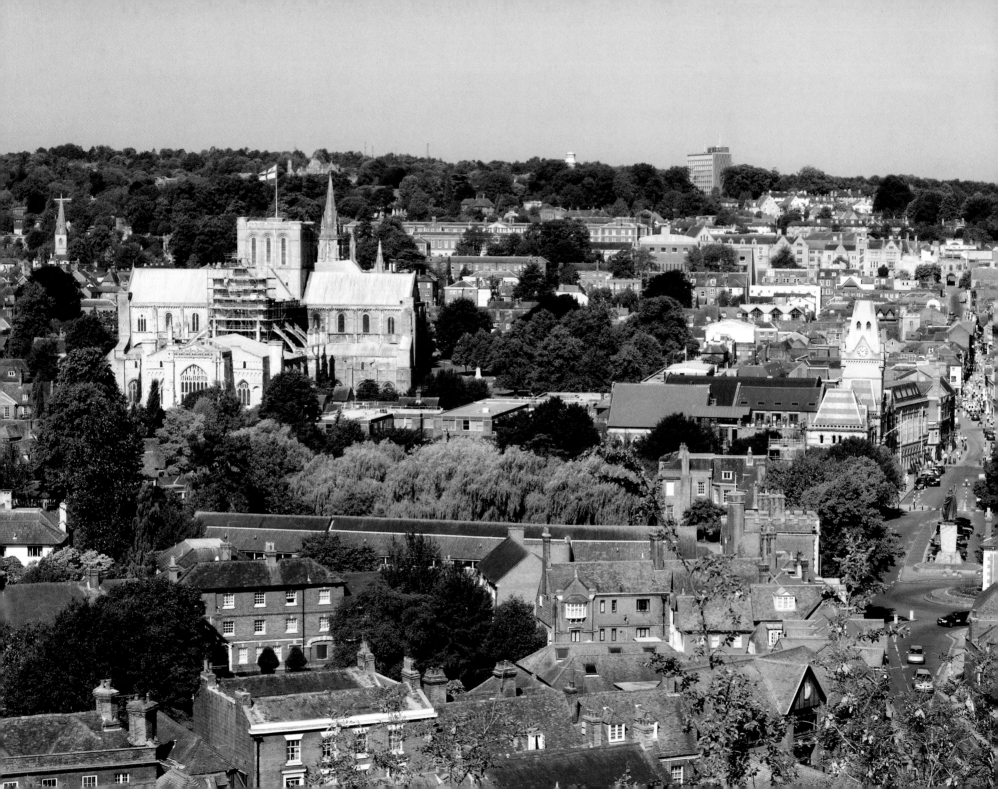

The High Cross – also known as the City or Butter Cross – at the hub of medieval Winchester
Opposite: Winchester, with the cathedral to the left and King Alfred's statue to the right

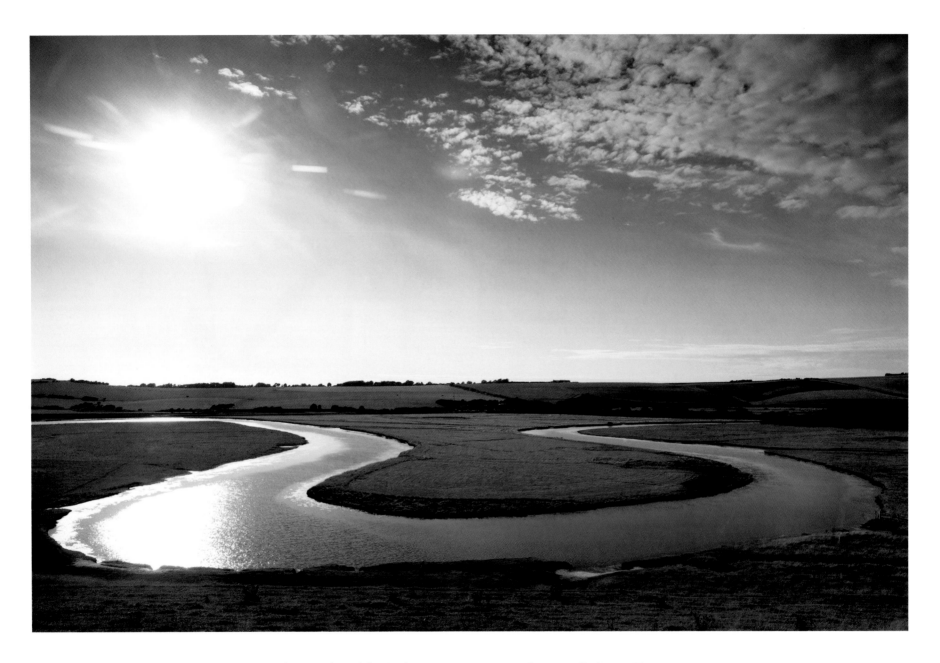

The meanders of the Cuckmere River as it nears the sea at Cuckmere Haven

Flint-fronted almshouses at East Meon

43

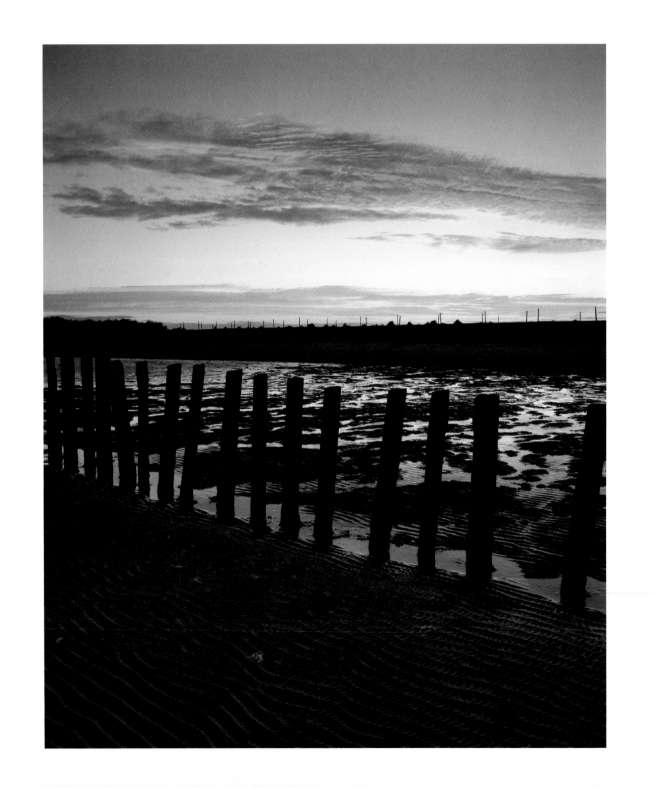

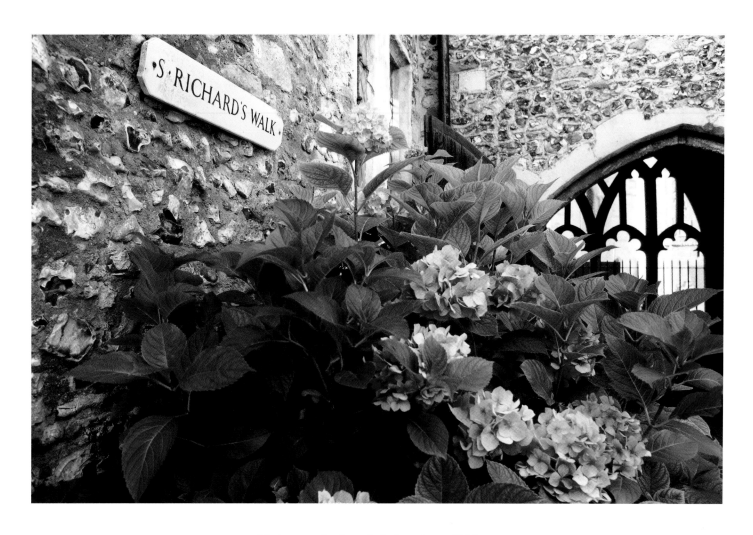

Hydrangeas in the cathedral precincts, Chichester
Opposite: Dawn at West Wittering beach, West Sussex

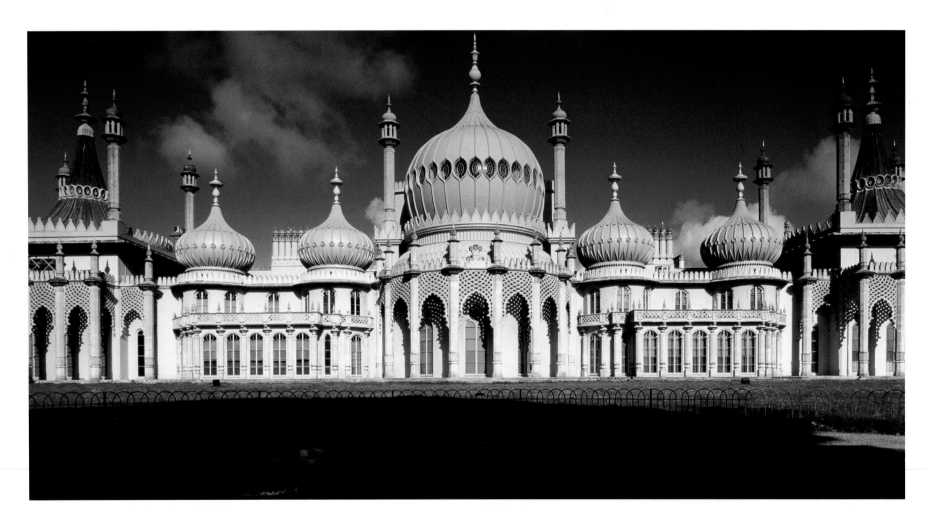

The splendour of the Royal Pavilion seen across the pond, Brighton

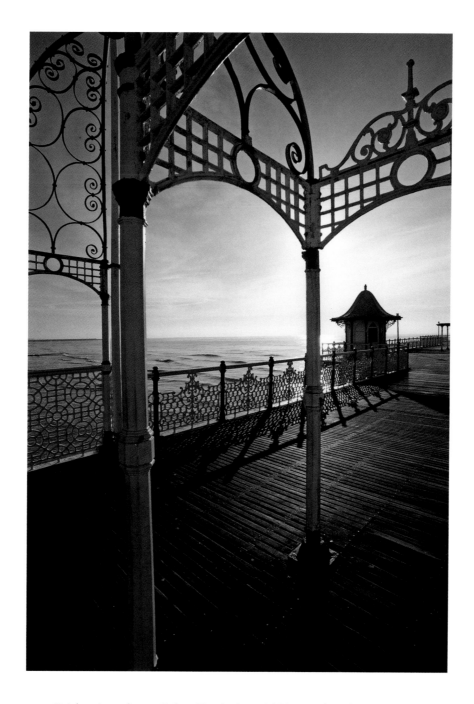

Brighton's exuberant Palace Pier, built in 1899 to replace the Chain Pier

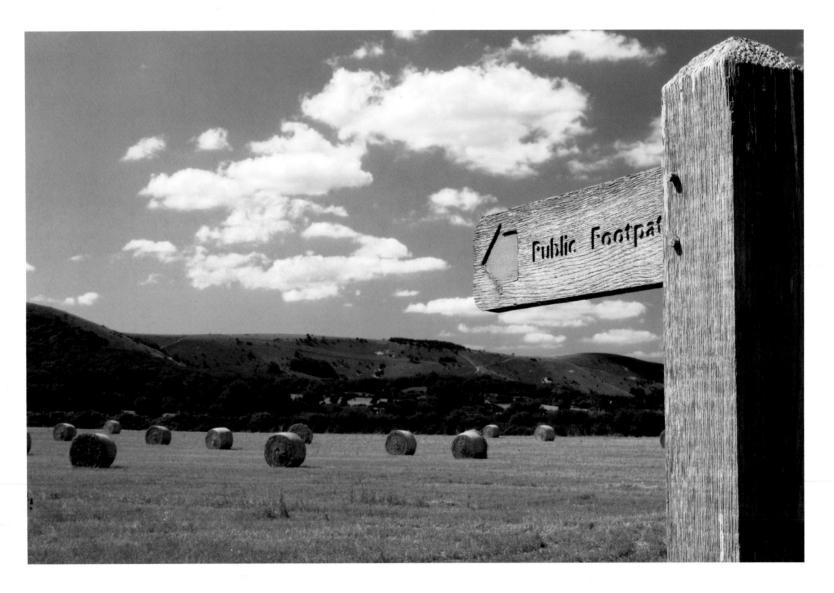

Hay bales at harvest time near Newtimber
Opposite: Coastguard cottages on Seaford Head, backed by the sheer chalk heights of the Seven Sisters

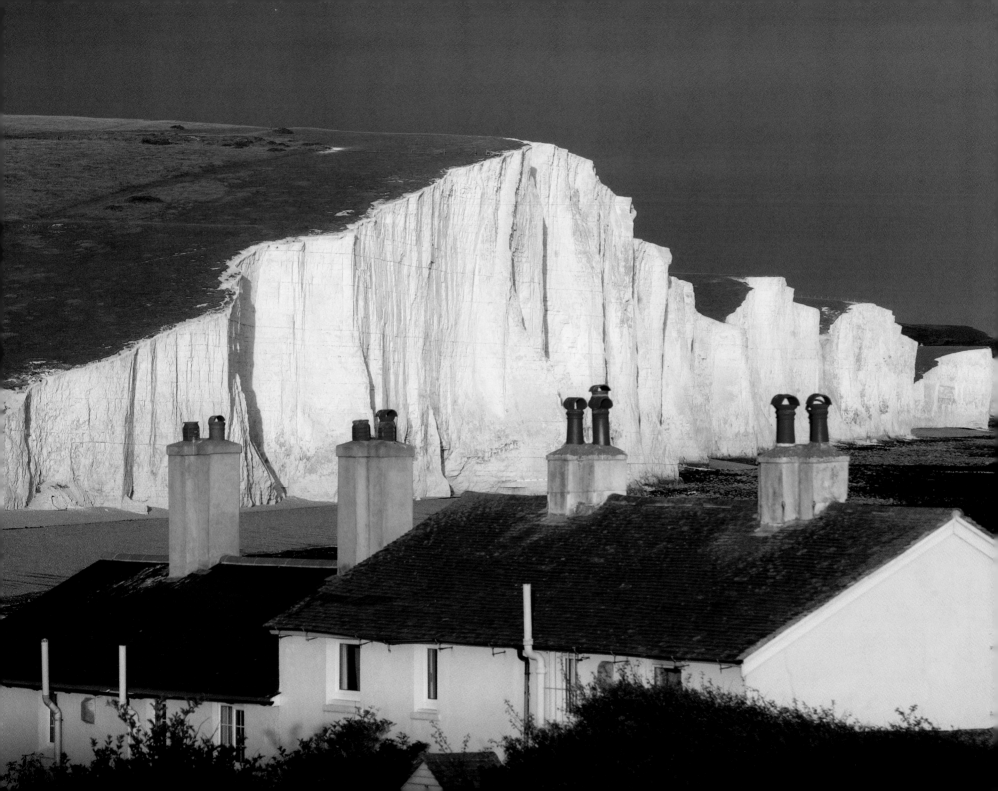

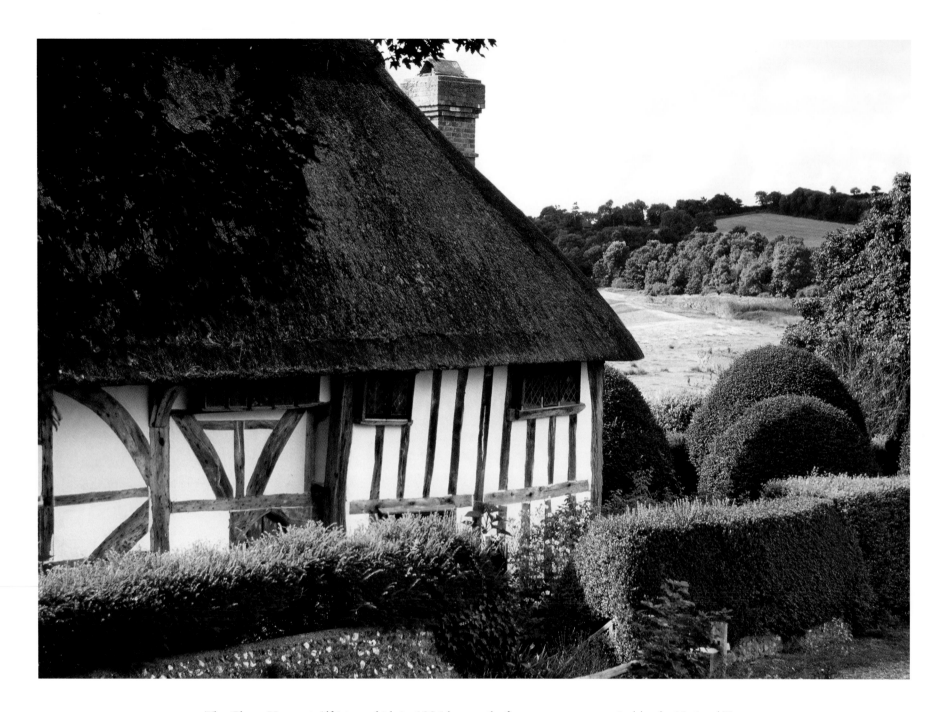

The Clergy House at Alfriston, which in 1896 became the first property ever acquired by the National Trust

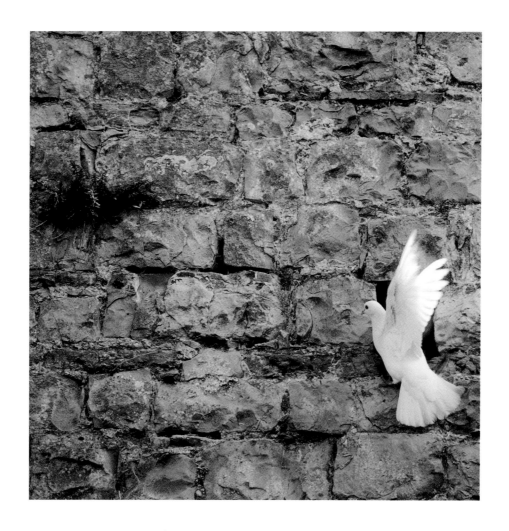

A dove perching on a niche of the walls of Amberley Castle

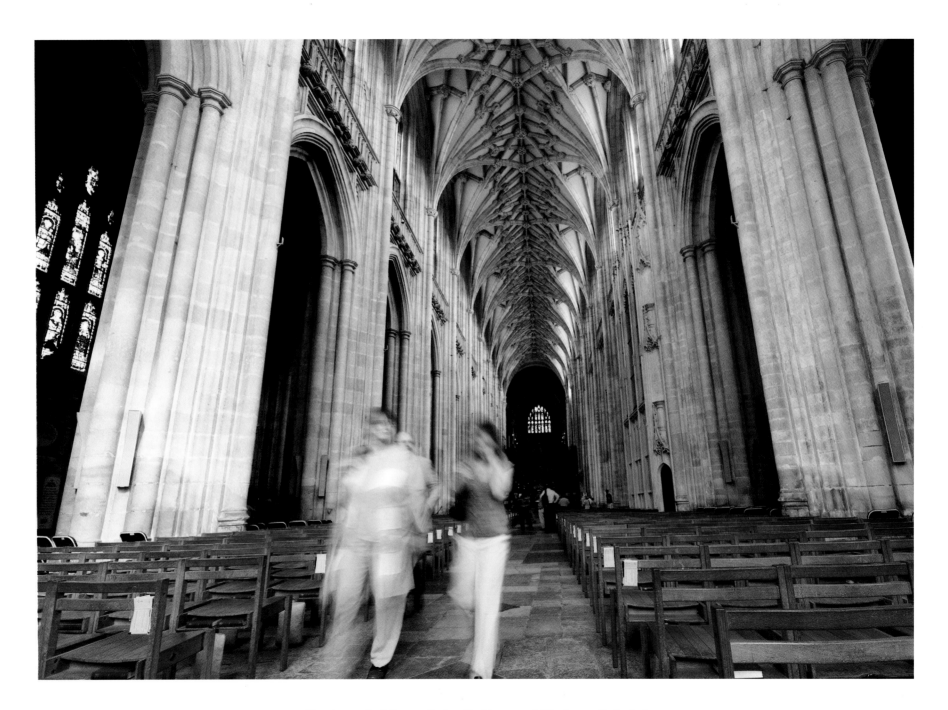

The fan-vaulted Perpendicular Gothic nave of Winchester Cathedral

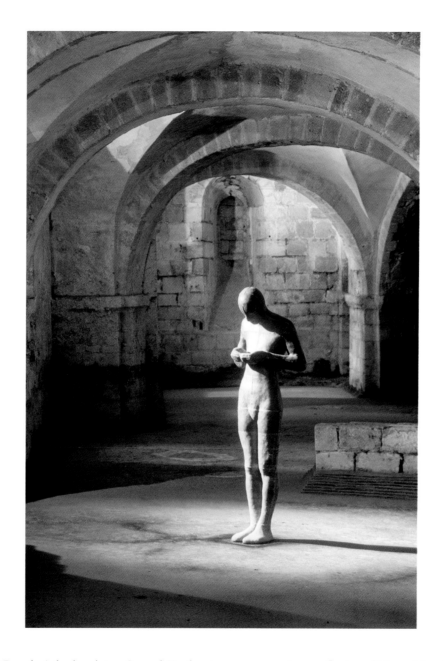

Antony Gormley's lead sculpture Sound II, *showing a person seeing a reflection of his soul in a bowl of water, stands in the Norman crypt of Winchester Cathedral*

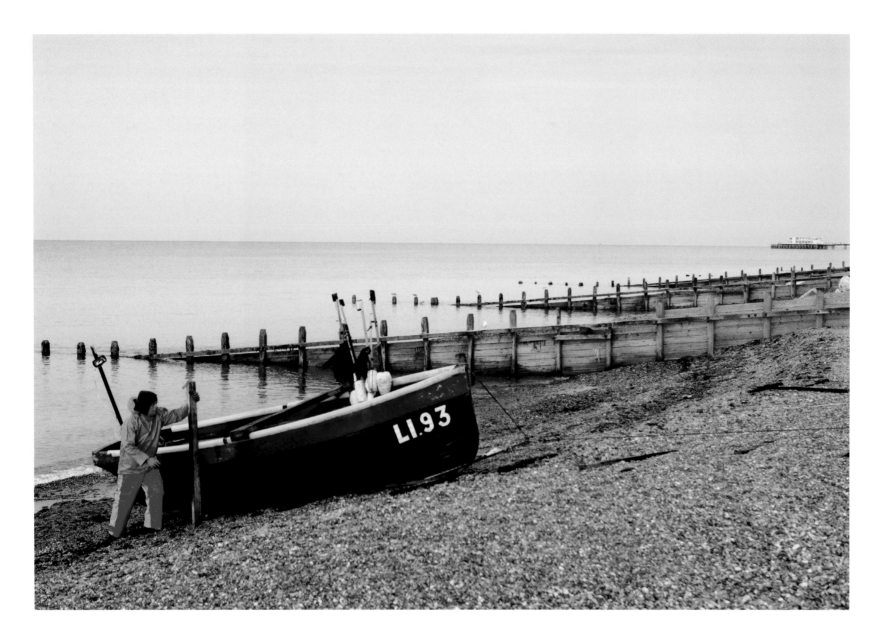

A fisherman lands his catch on the shingle beach at Worthing

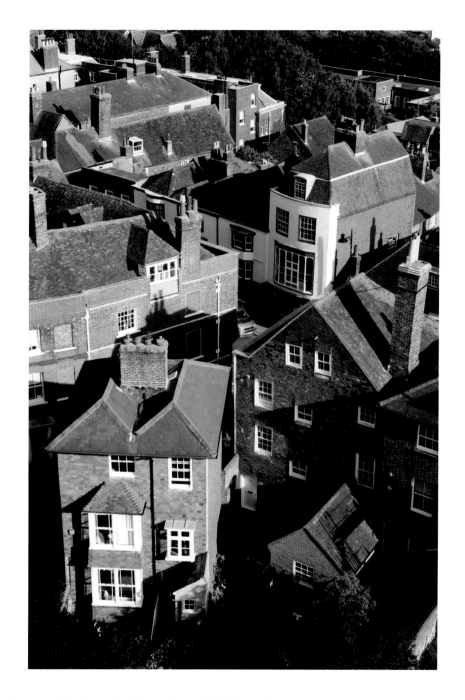

Georgian façades and tile-hung houses huddle round yards and streets below Lewes Castle

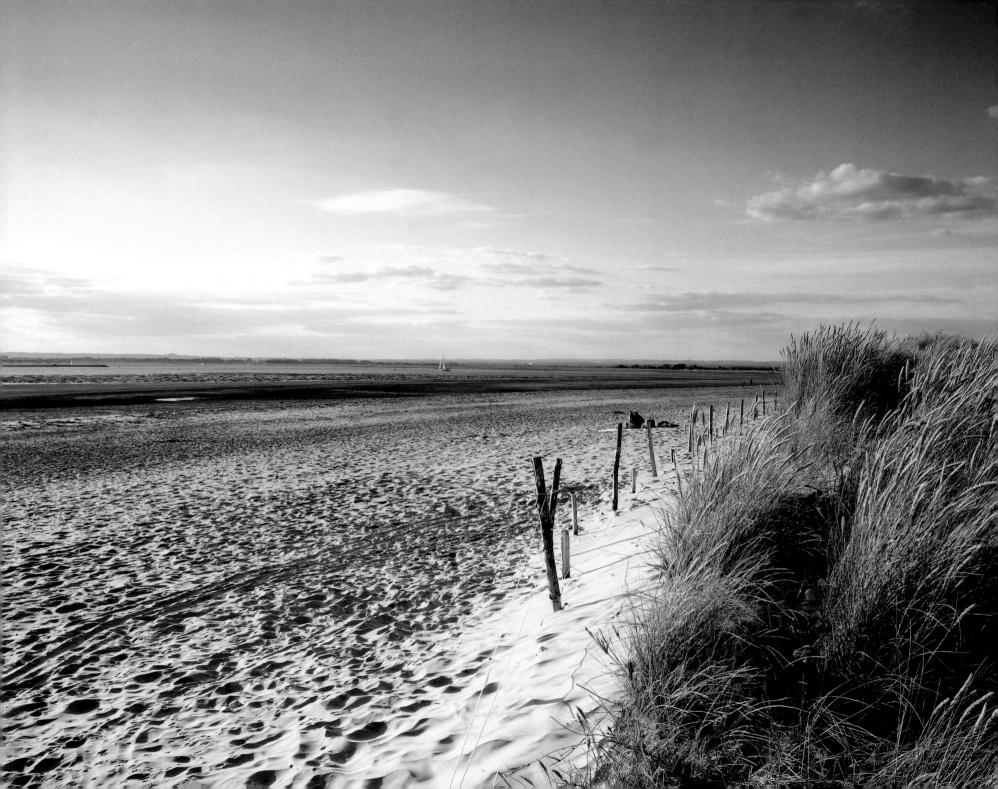

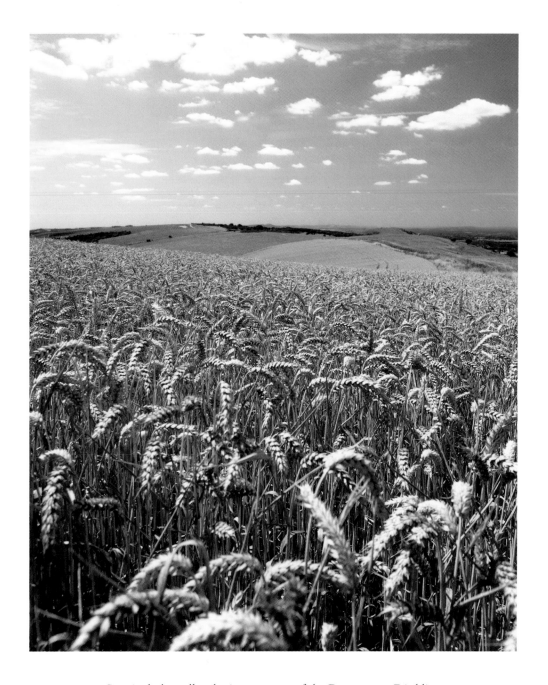

Seemingly boundless horizons on top of the Downs near Ditchling

Opposite: West Wittering, one of the very few substantial sandy beaches in Sussex

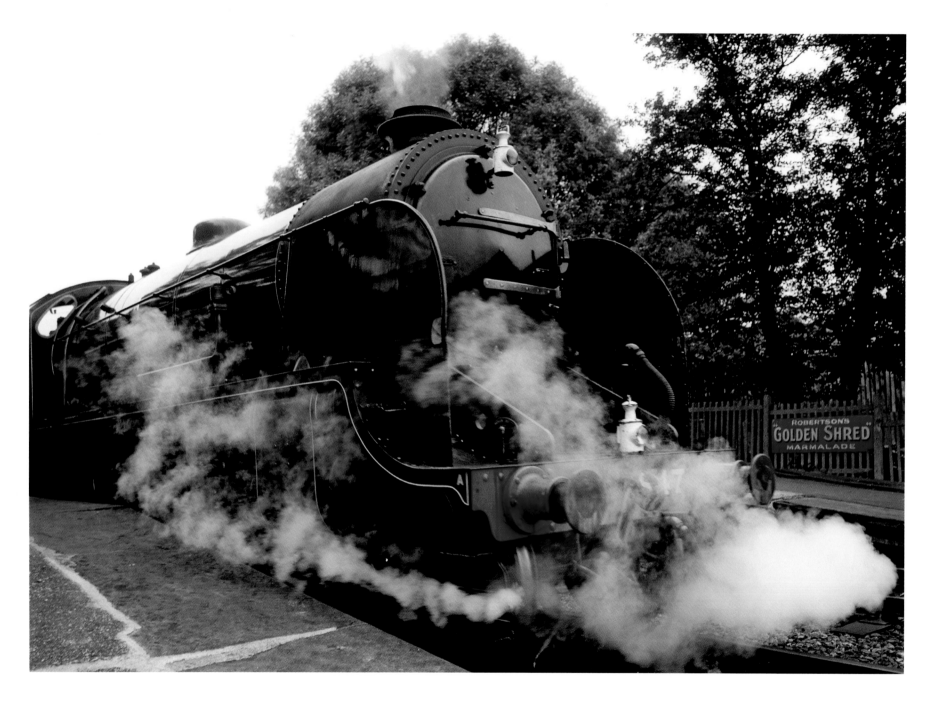

A locomotive steams along the Bluebell Railway, one of Britain's earliest preserved heritage railways

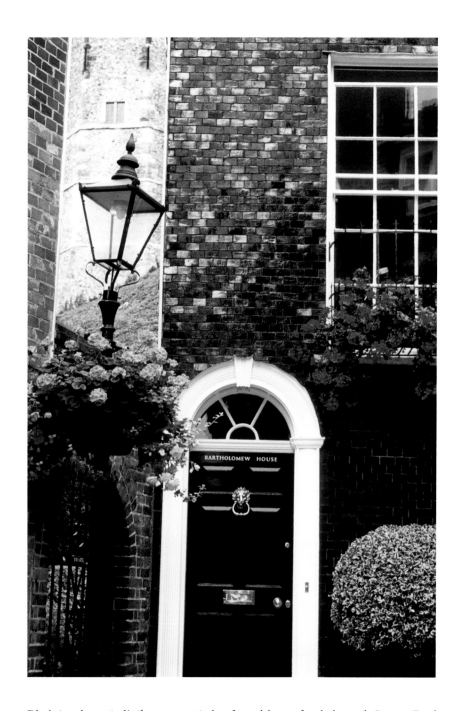

Black 'mathematical' tiles cover a timber-framed house façade beneath Lewes Castle

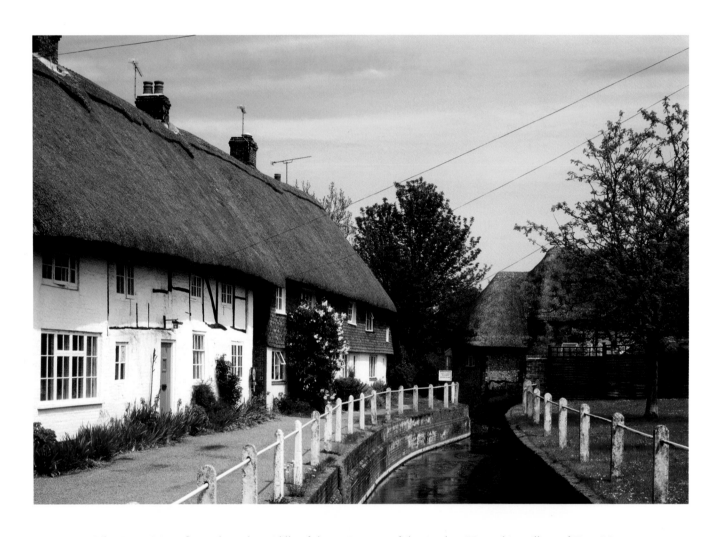

The River Meon flows along the middle of the main street of the timeless Hampshire village of East Meon
Opposite: No one knows the date or purpose of the Long Man of Wilmington, cut into the chalk of the escarpment

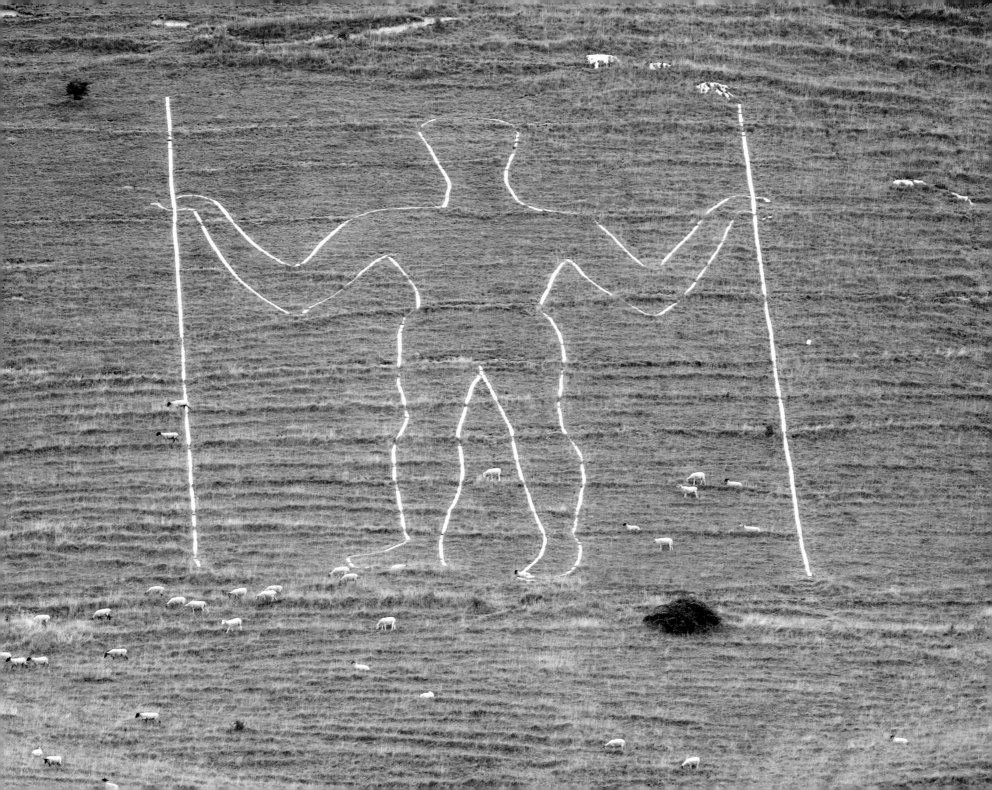

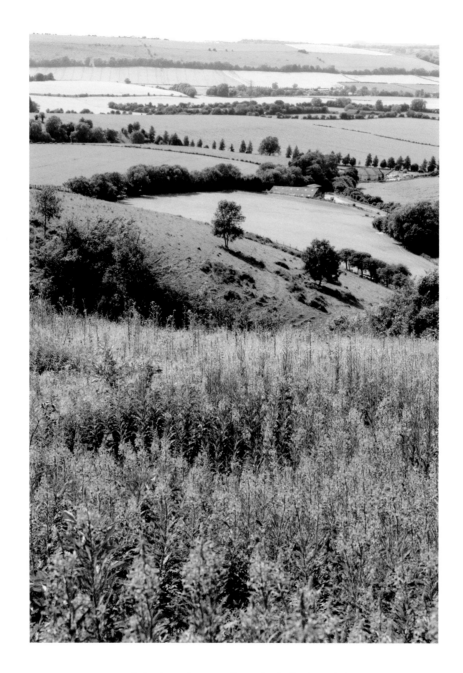

From Butser Hill, looking downwards to the hedge-line fields of the Weald

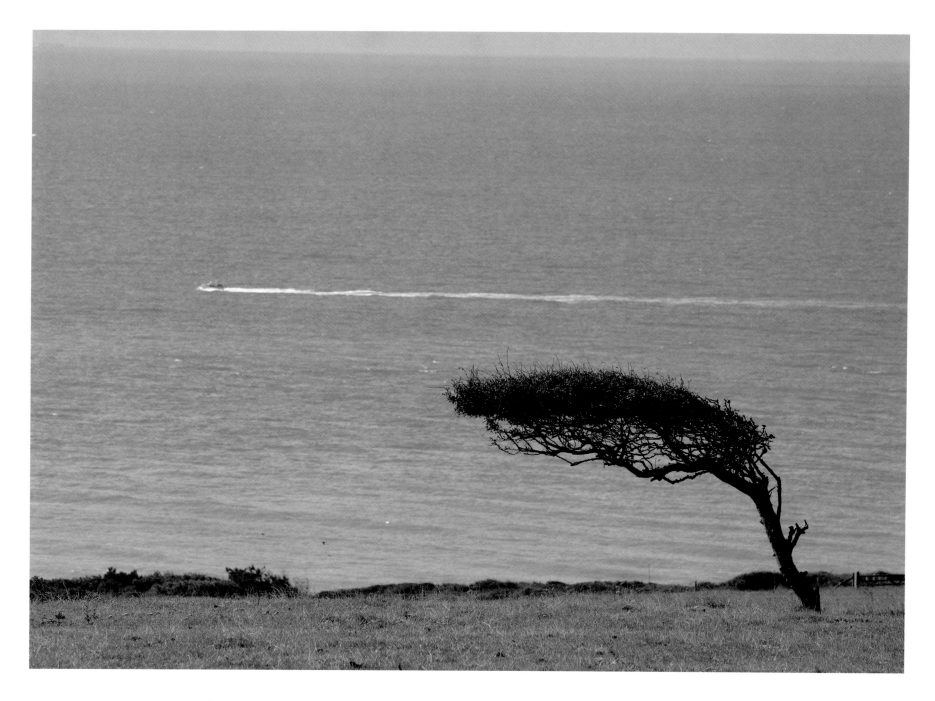

A tree on the Seven Sisters sculpted by the prevailing wind and restricted in growth by the thin chalk soil

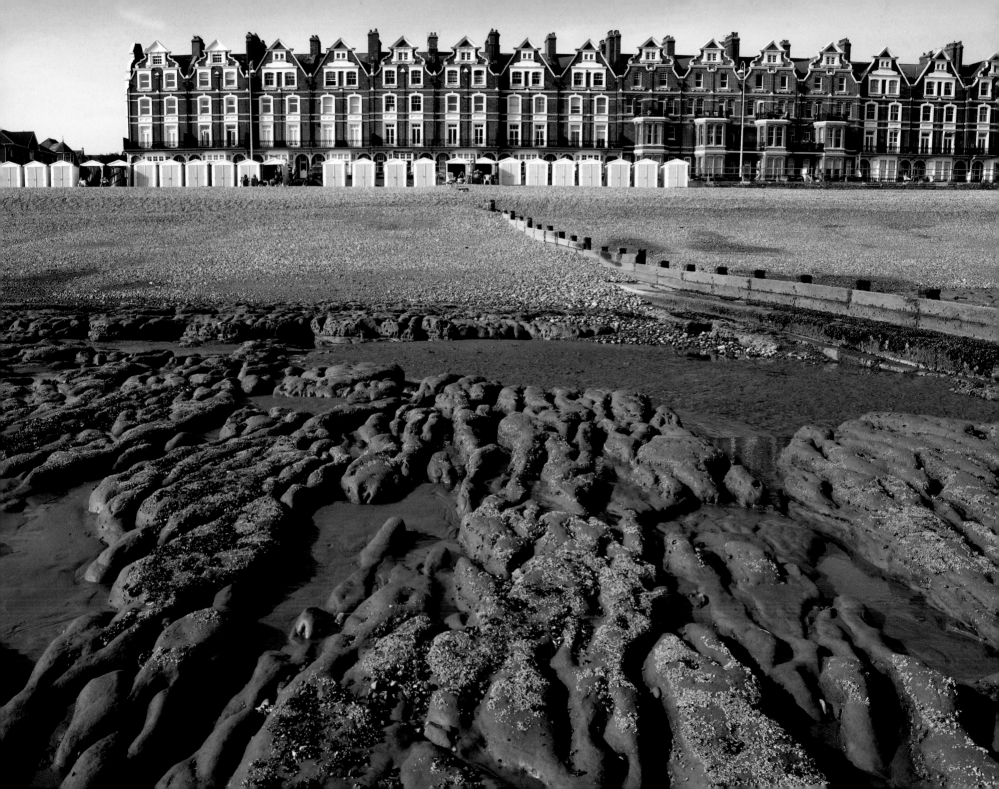

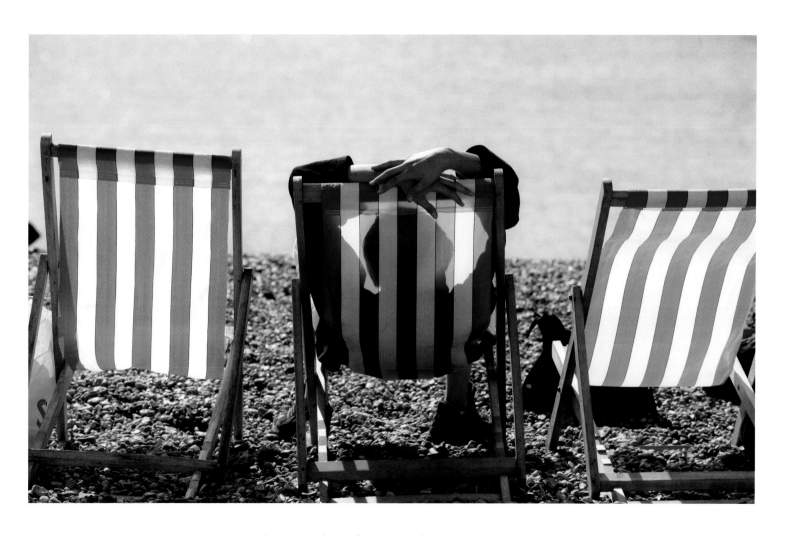

Calm contemplation from a deck chair on Brighton beach
Opposite: Dutch-gabled houses above the beach huts at Bexhill

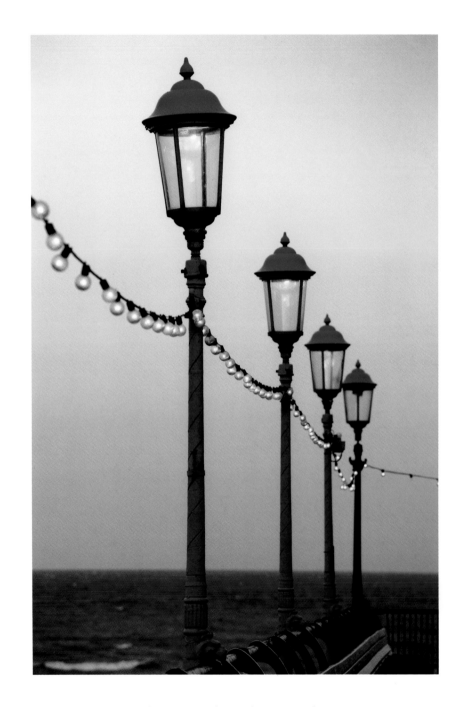

Dusk sets in on the sea front at Eastbourne

Georgian façades along the handsome High Street in Lewes

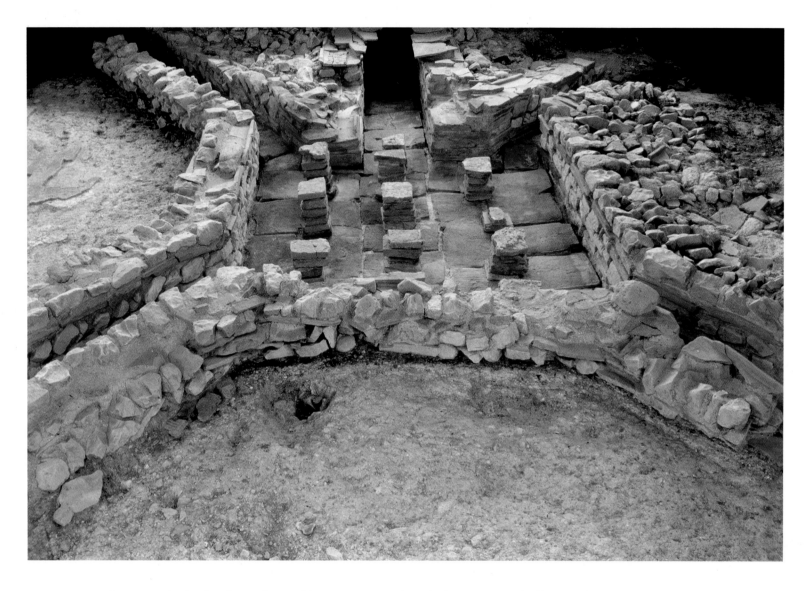

Hypocaust (under-floor heating) at Fishbourne Roman Palace, the largest Roman building yet found north of the Alps
Opposite: Detail of a mosaic, Fishbourne Roman Palace near Chichester

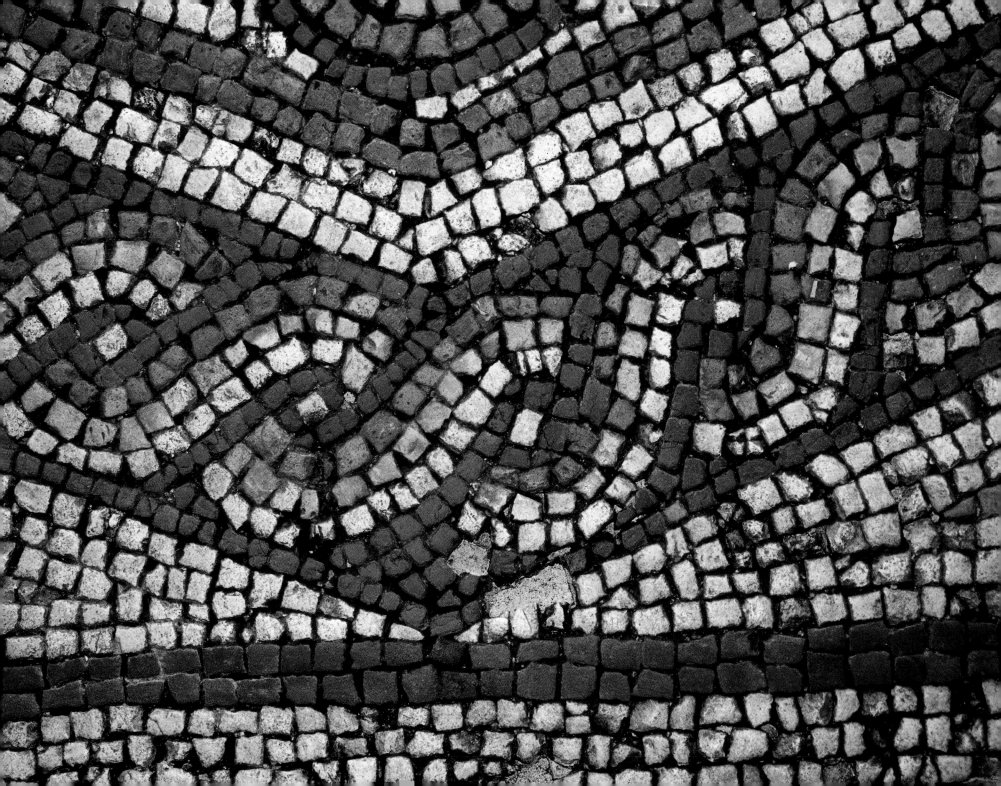

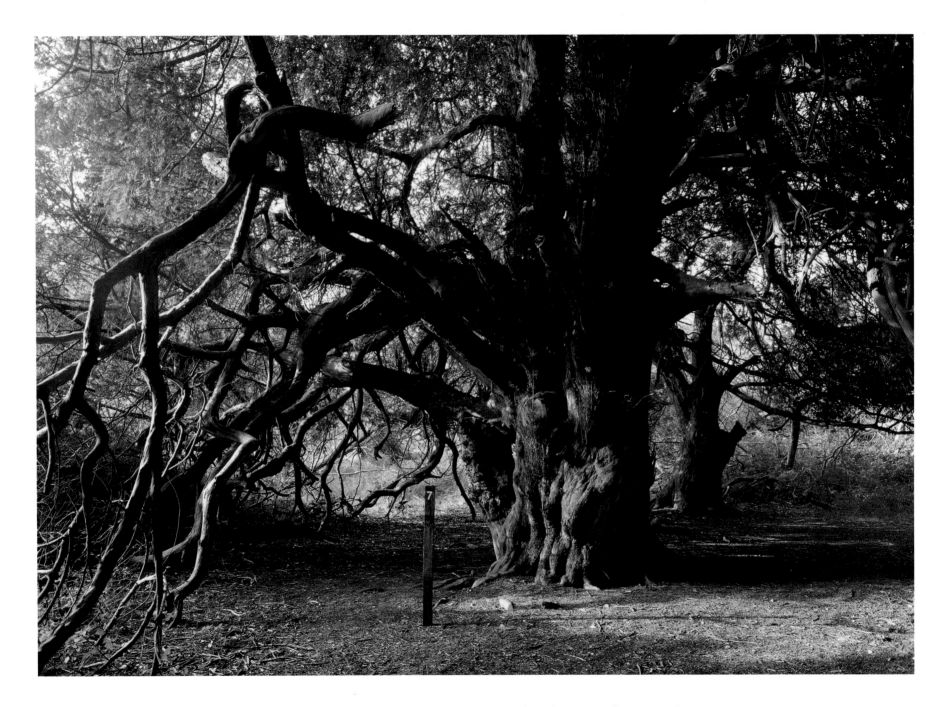

An ancient grove of fantastically shaped trees at Kingley Vale, Europe's largest yew forest

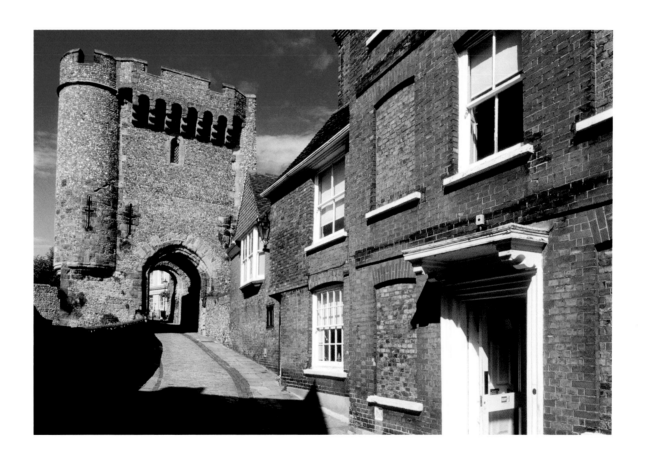

The medieval Barbican at Lewes Castle, with the older Norman archway seen just beyond

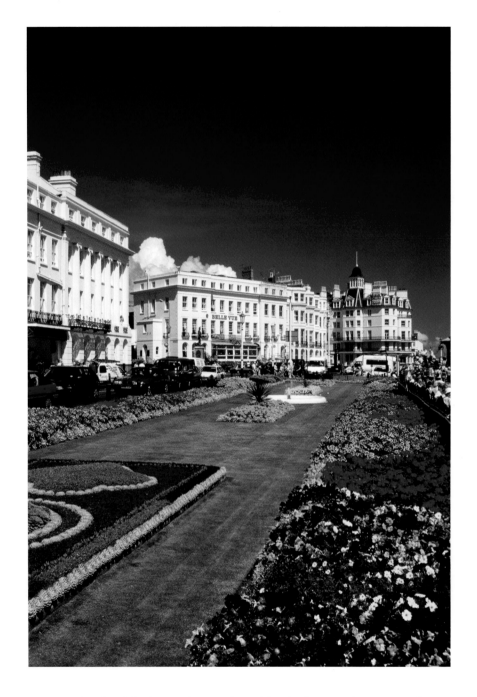

Immaculate floral displays and stucco-fronted hotels along Eastbourne's sea front

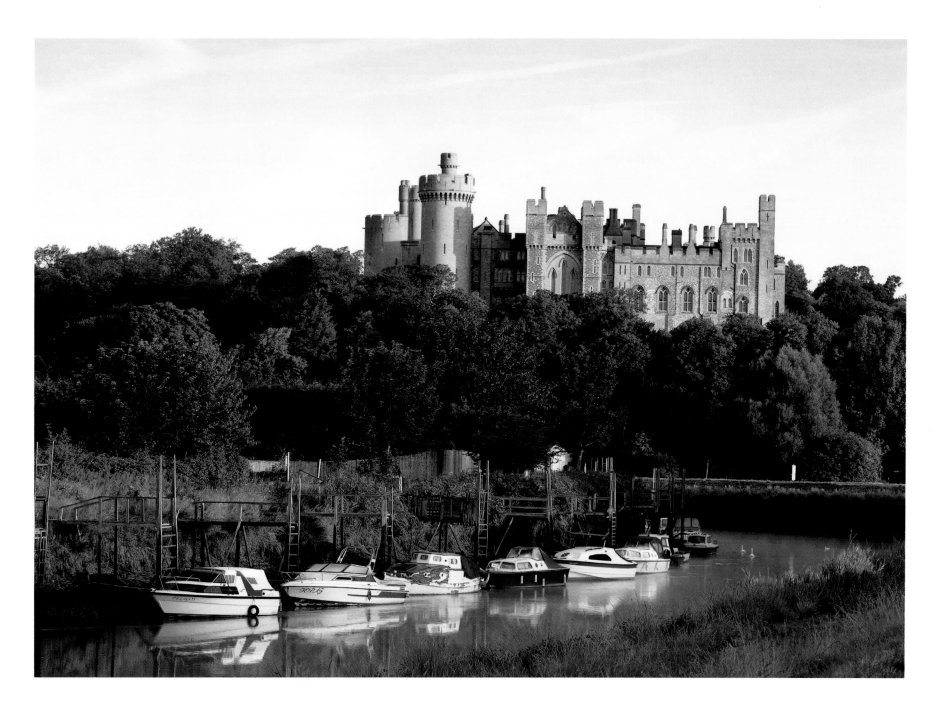

The battlements of Arundel Castle tower above the River Arun at Arundel

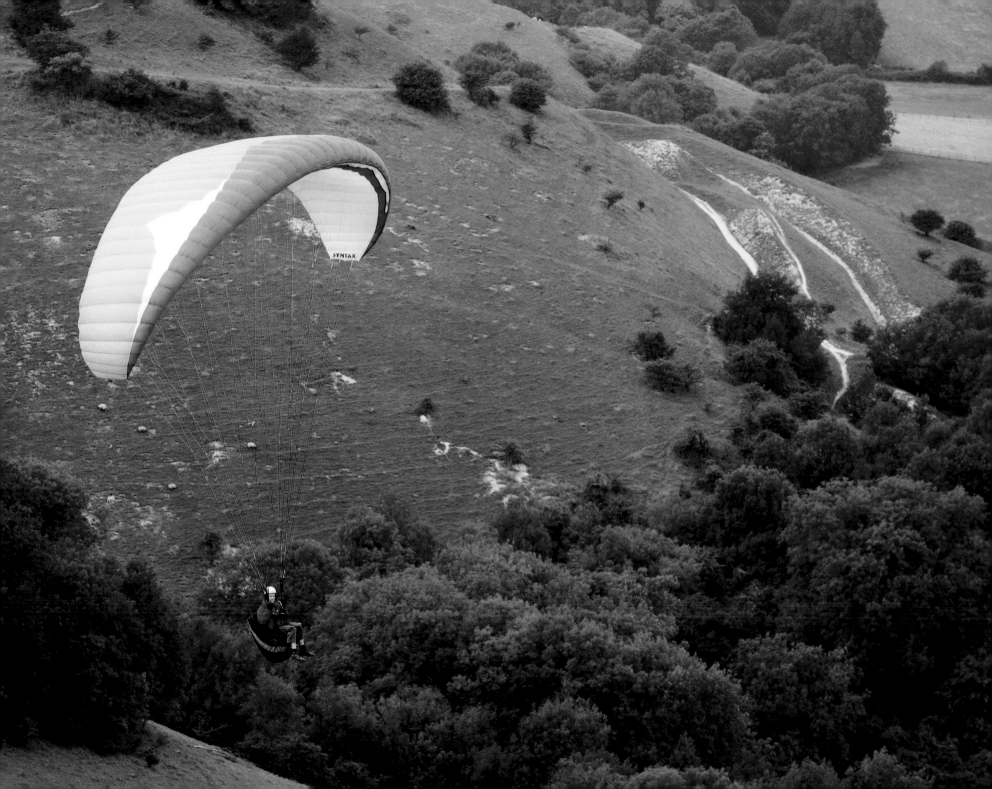

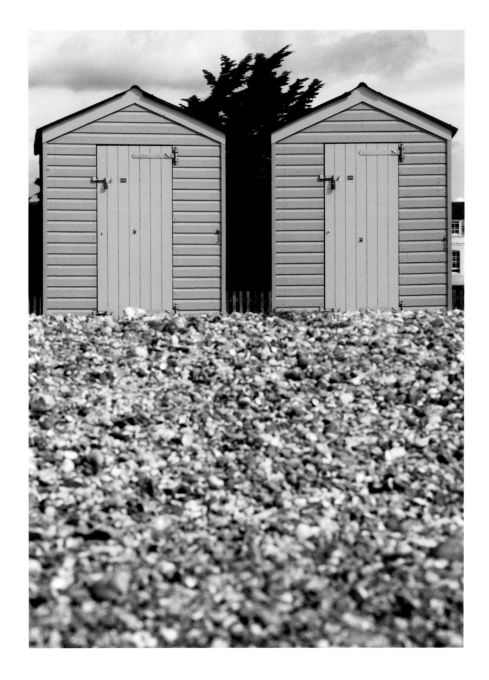

Two of Sussex's many beach huts: these are at Littlehampton
Opposite: A paraglider's view over the dramatic deep valley of Devil's Dyke

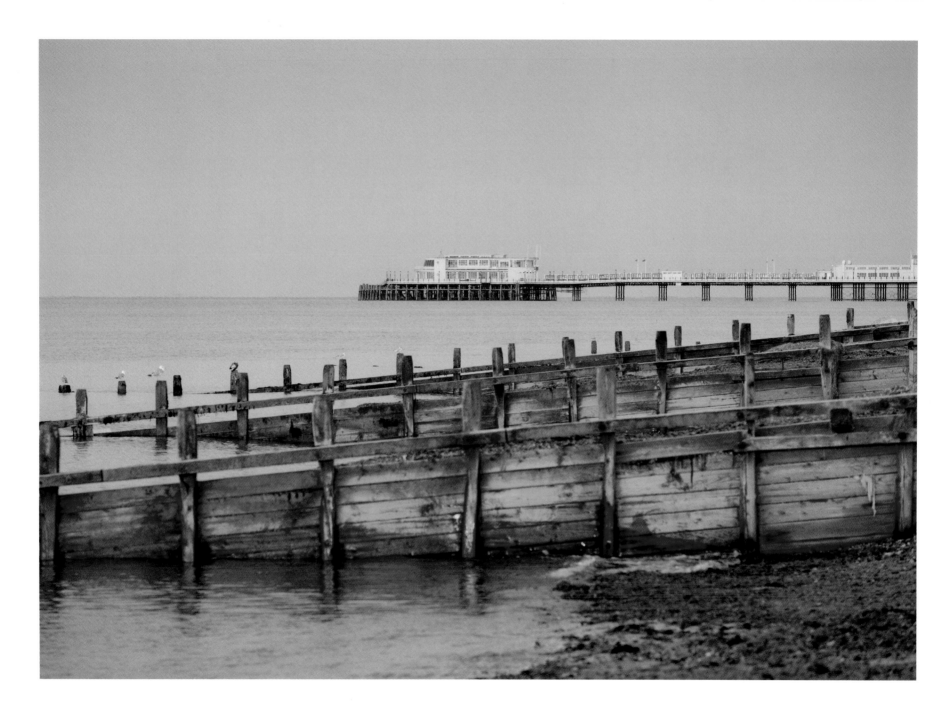

Along the coast to Worthing's Art Deco pier

76

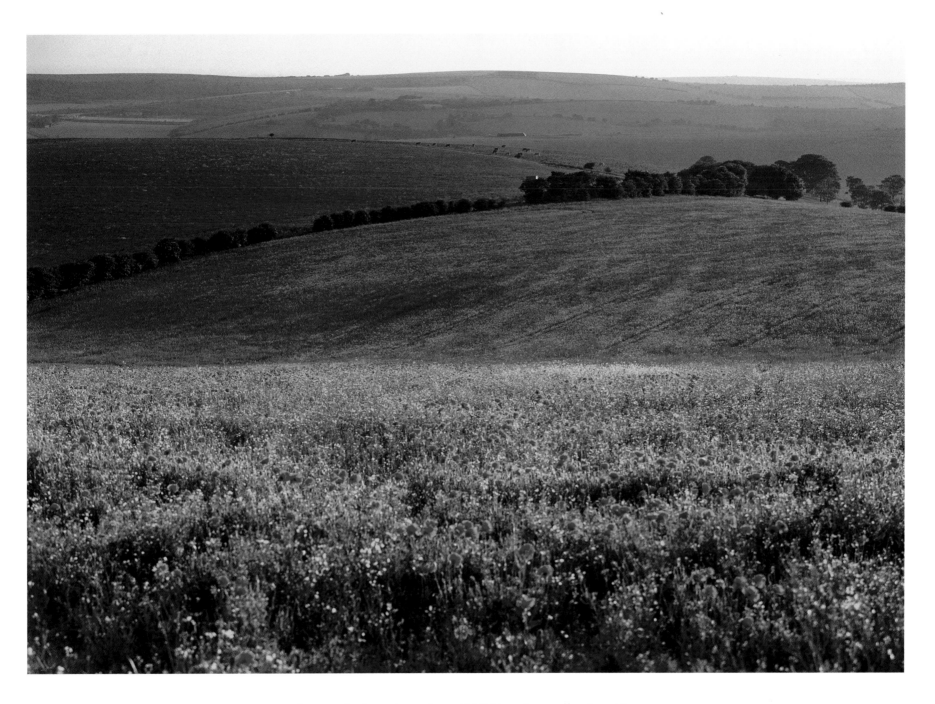

Carpets of red poppies on 'set-aside' fields make a spectacular tableau

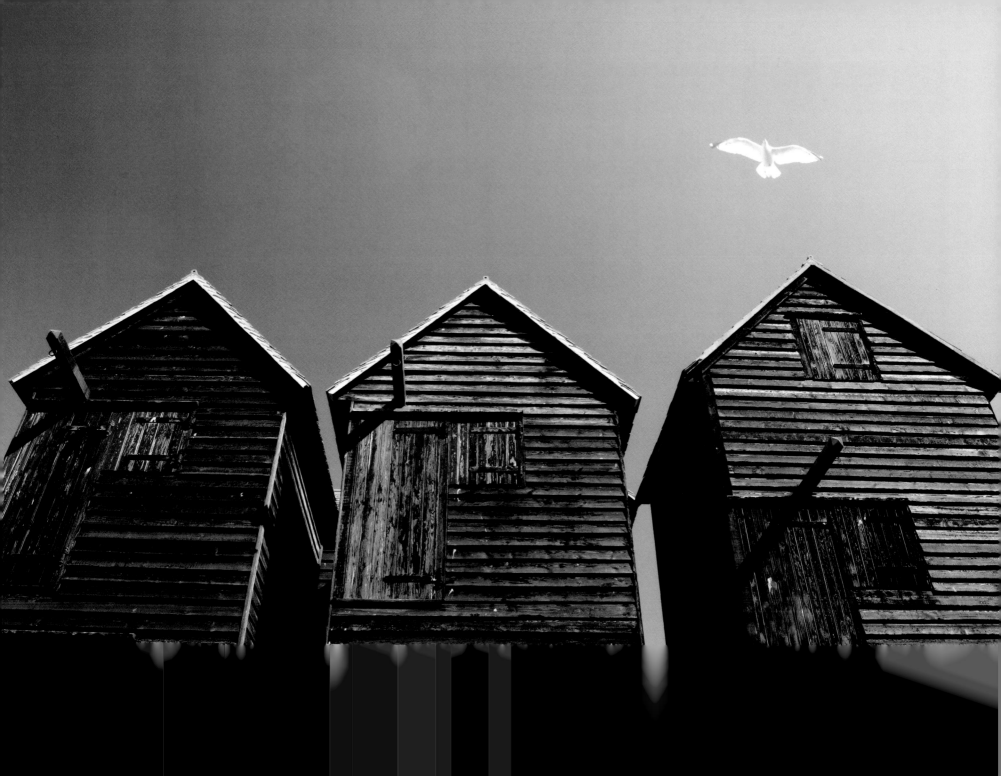

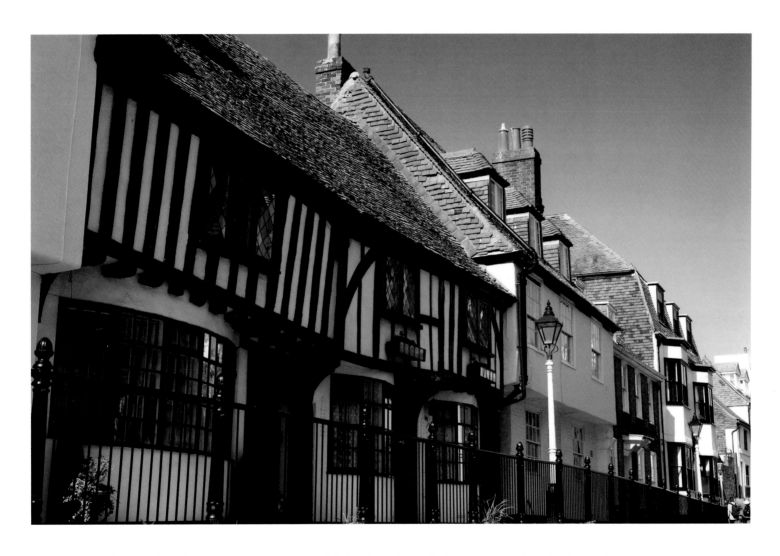

Hastings Old Town, a captivating warren of timber-framed and tile-hung cottages, stepped alleys and steep hillsides
Opposite: Hastings' lovingly preserved Net Houses, erected for storing fishing nets, by the beach

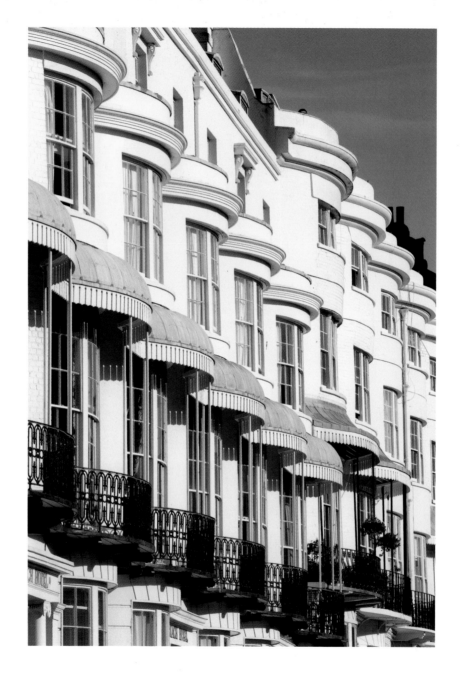

Regency elegance in Brighton's Regency Square
Opposite: Sunset hues on the water beneath Brighton's Palace Pier

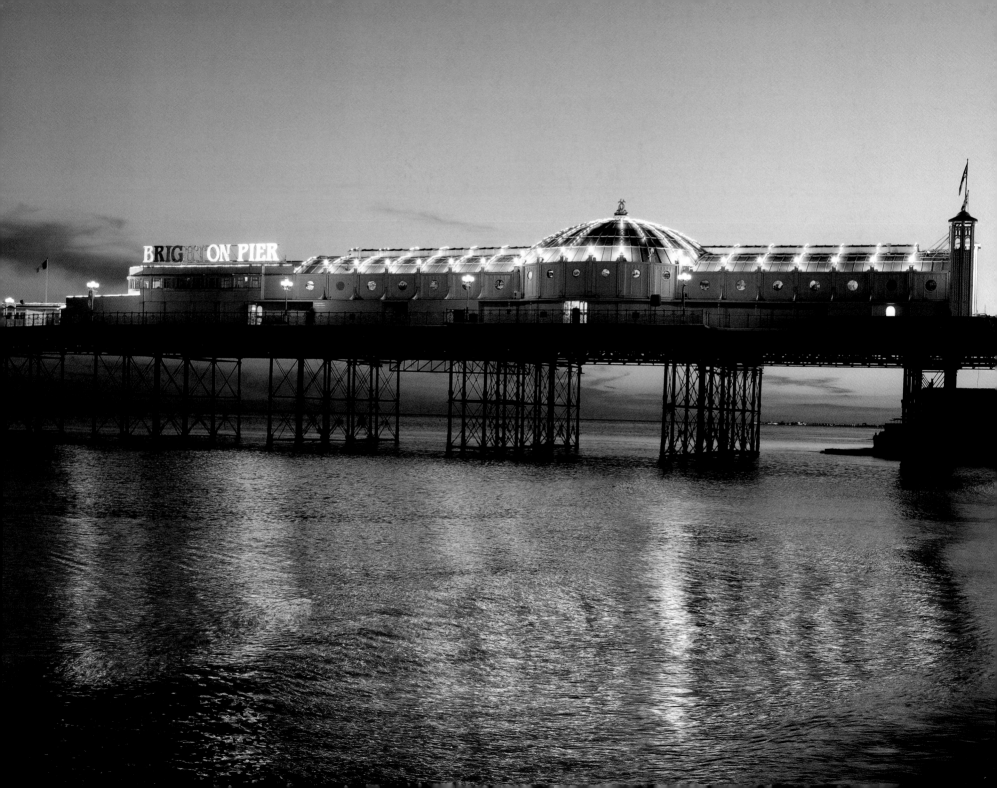

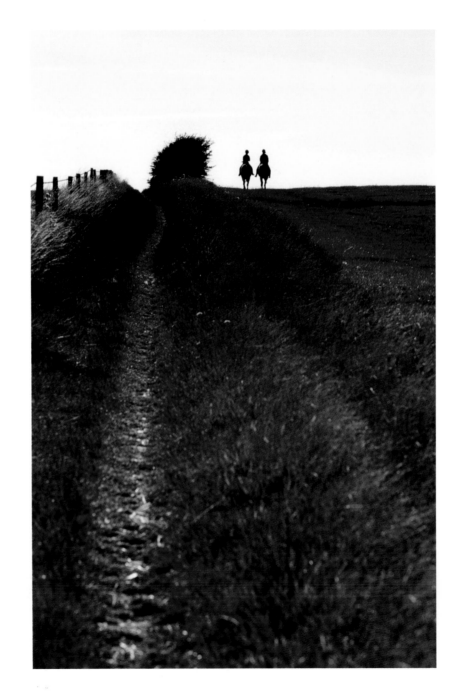

Horseriders on Newtimber Hill, near Devil's Dyke

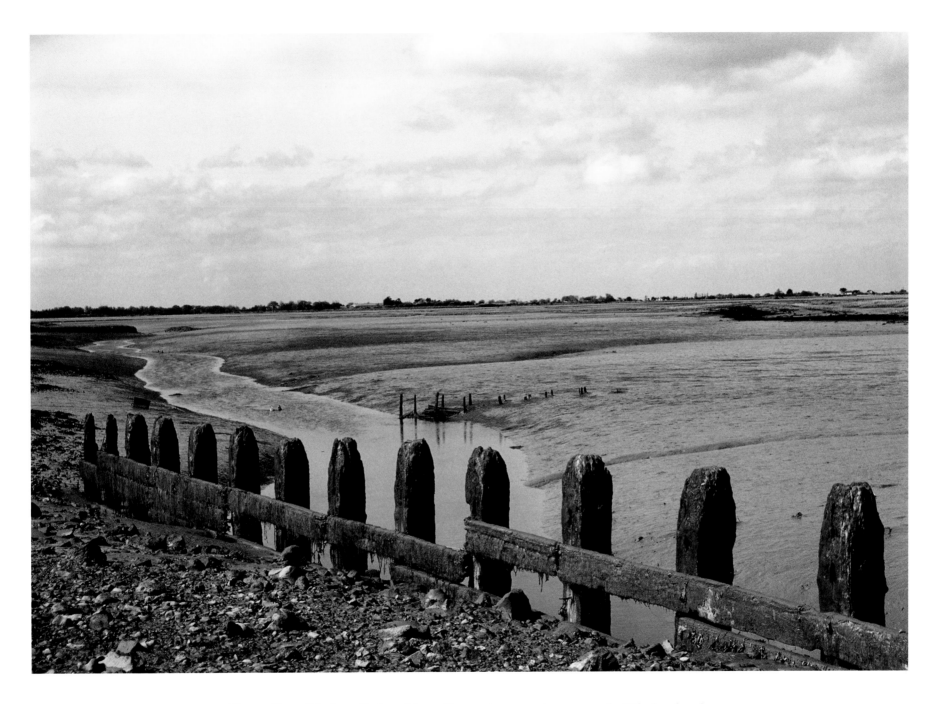

The mudflats of Pagham Harbour Nature Reserve, home to a huge range of wildfowl and waders

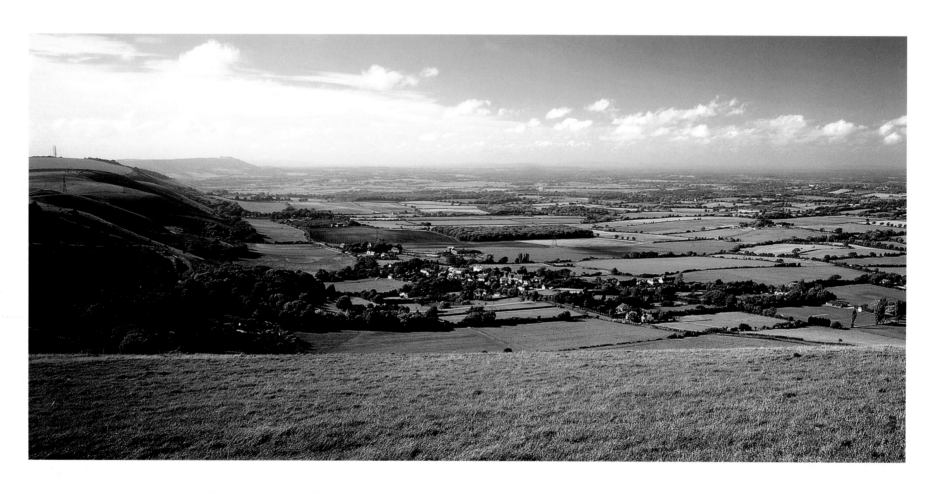

The view northwards from Devil's Dyke, over the Weald and towards the Surrey hills and North Downs
Opposite: Prime beach-combing territory beneath the cliffs at Birling Gap

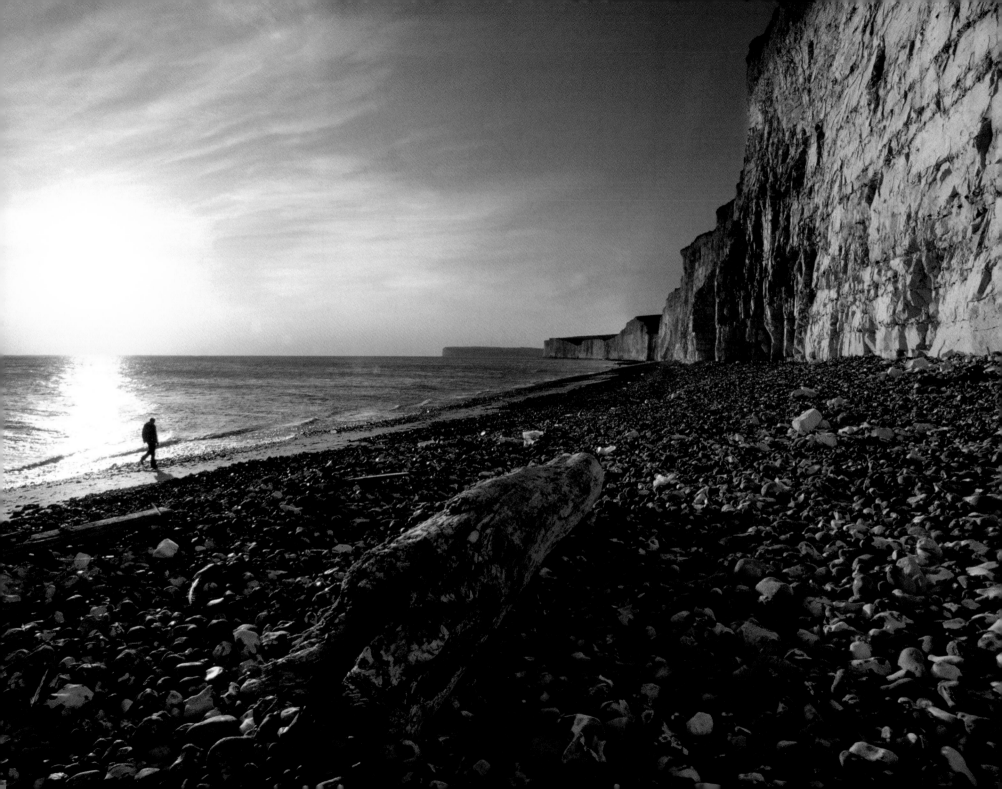

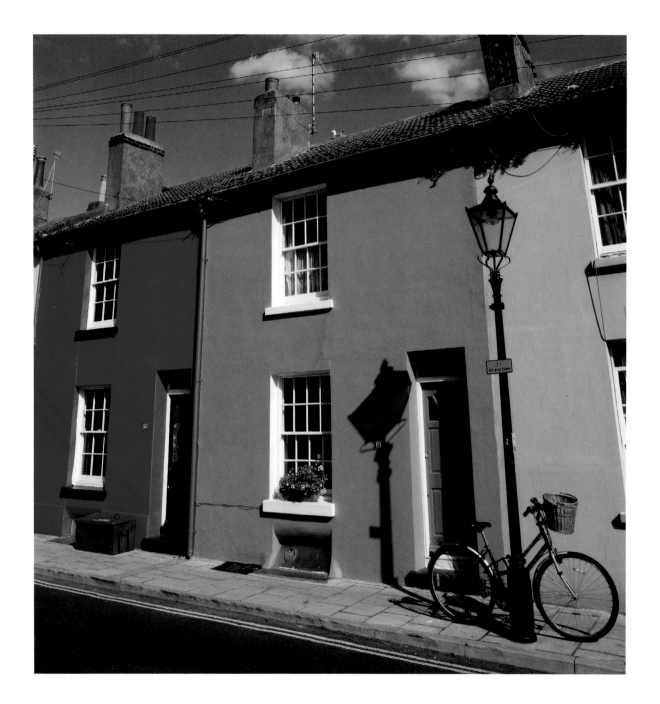

Bohemian chic: Victorian houses in the trendy North Laine area of Brighton

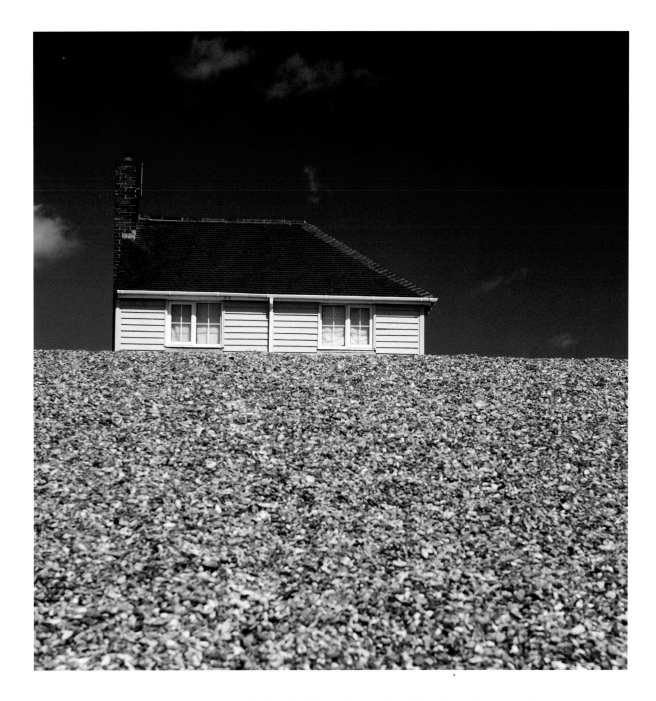

Solitary and surreal, a weatherboarded house above a shingle bank on the Sussex shore

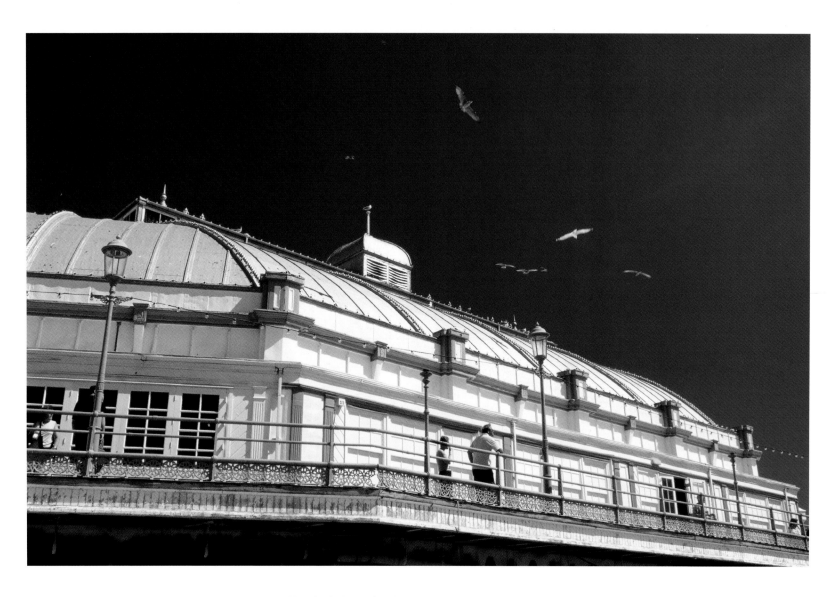

Gulls wheel above the blue and white pier at Eastbourne

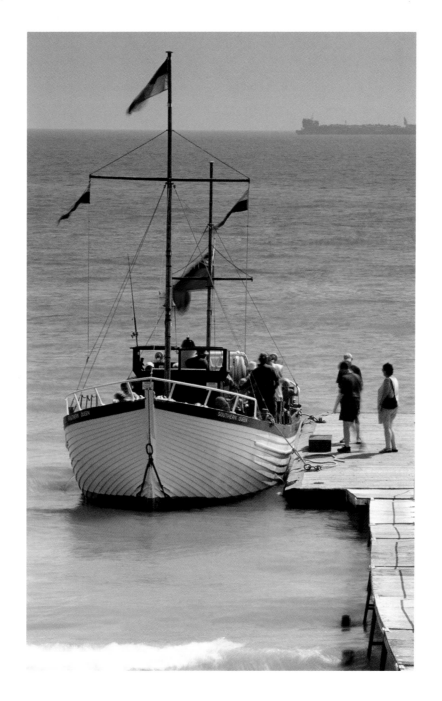

Visitors board a classic Sussex Beach Boat for a cruise out towards Beachy Head

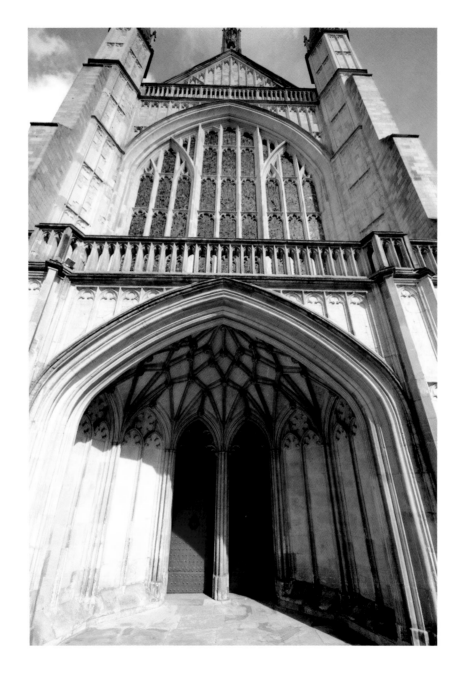

Winchester Cathedral, burial place of Jane Austen, Izaak Walton and William Rufus
Opposite: Red sky at night: over the sea towards Seaford Head

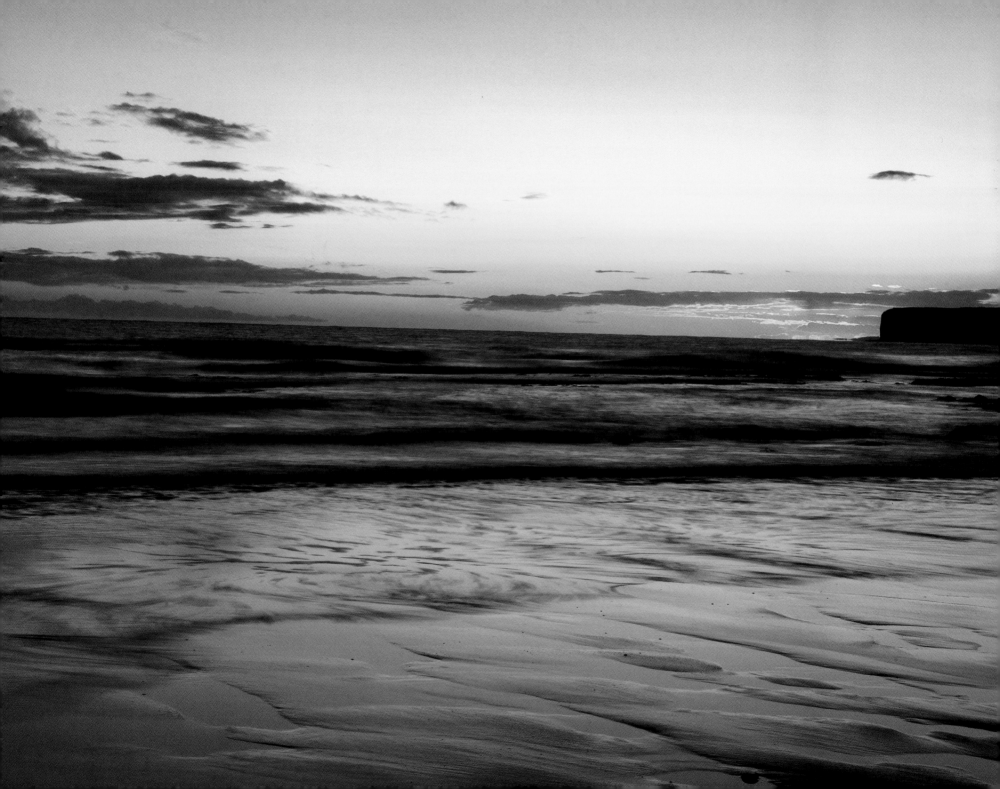

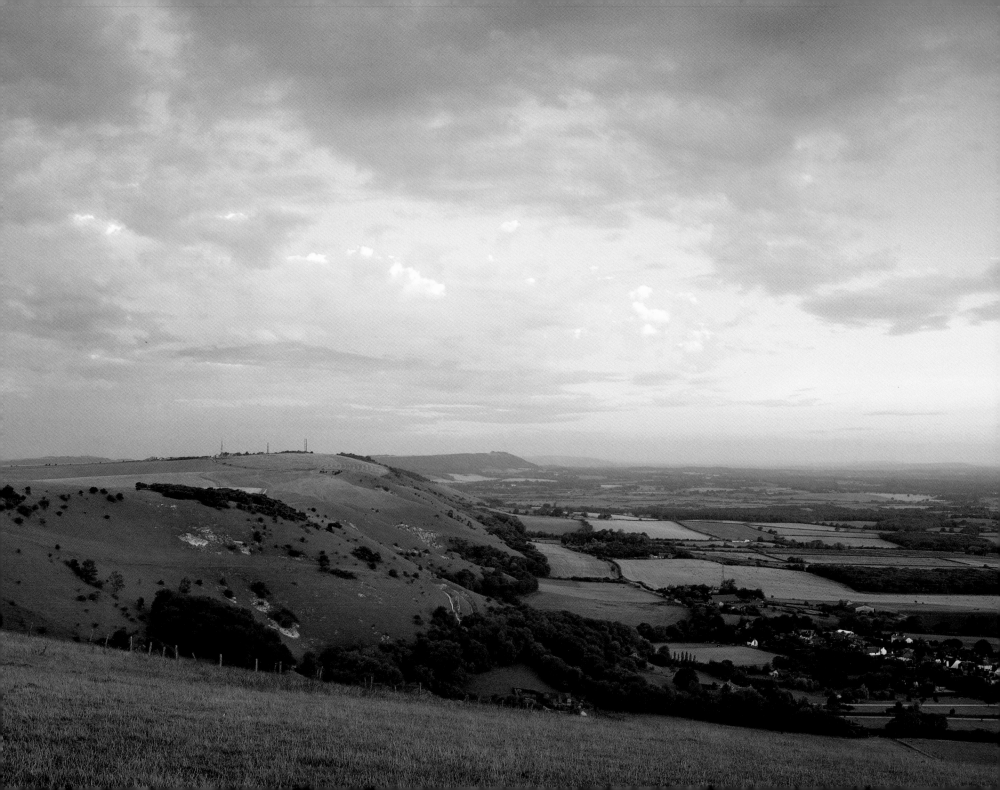

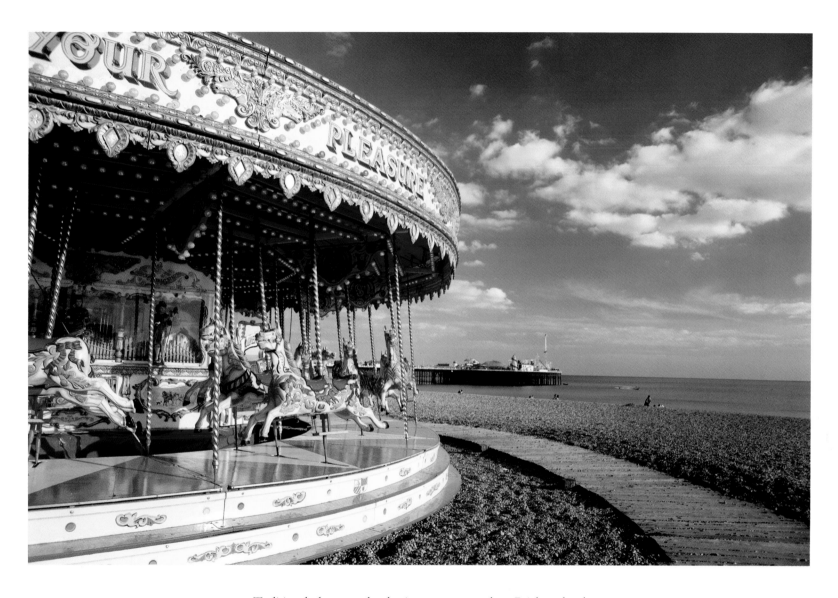

Traditional pleasures: the classic merry-go-round on Brighton beach
Opposite: Devil's Dyke, Britain's largest dry chalk valley, home to numerous butterflies

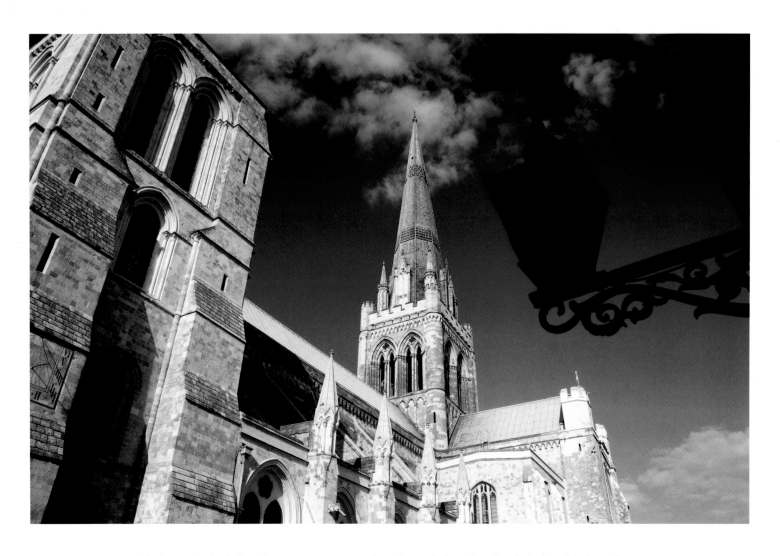

Chichester Cathedral, with its soaring spire – the only English medieval cathedral visible from the sea
Opposite: Sheep pastures high on the Downs

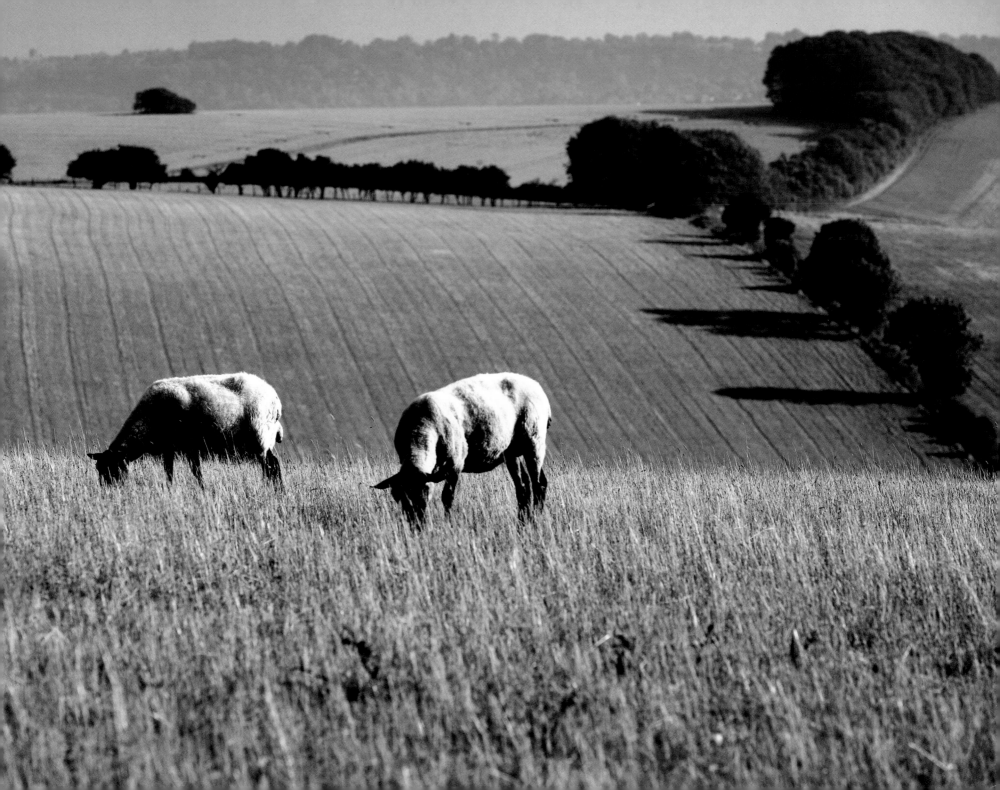

INDEX